D0845581

MARC BELL PRESENTS

THE MAGICAL WORLD OF
M.C. ESCHER

BOCA RATON MUSEUM OF ART

JANUARY 20 – APRIL 11, 2010

M.C. Escher

This catalog has been published in conjunction with the exhibition

MARC BELL PRESENTS

THE MAGICAL WORLD OF M.C. ESCHER

JANUARY 20 — APRIL 11, 2010

. .

BOCA RATON
MUSEUM OF ART

501 PLAZA REAL
BOCA RATON, FLORIDA 33432

T 561.392.2500
F 561.391.6410
E info@bocamuseum.org

www.bocamuseum.org

OFFICIAL MUSEUM OF ART FOR THE CITY OF BOCA RATON

. .

IN COOPERATION WITH:

ROCK J. WALKER & WALKER FINE ART, INC.

T 347.563.2100
E rockartusa@msn.com

www.rockjwalker.com

. .

CONCEPT: *Rock J. Walker & Salvatore Iaquinta*

DESIGN: *Brian Black, Black Design, Inc.*

PRINTED AND BOUND BY: *Southeastern Printing*

ISBN 978-0-936859-81-1

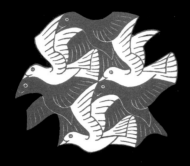

EDUCATION
S
SCIEN**C**E
MAT**H**EMATICS
E
A**R**T

DEDICATION

May you share a growing love of learning
as a result of this experience.

Invest your time, energy, and money in our
children and their teachers, for education is
the only real deterrent to our most severe
and serious social problems.

Enjoy!

Rock J. Walker

Contents

Explanation of Annotations and Inventory Numbers i

Acknowledgment 1
GEORGE S. BOLGE

The Magical Work of M.C. Escher 3
WILLEM F. VELDHUYSEN

Filling the Void 5
FEDERICO GIUDICEANDREA

The Reluctant Pop Culture Phenom 10
SALVATORE IAQUINTA

Plates 15

Flor de Pascua 22

Escher Memories: How Italy Shaped the Future 32
SALVATORE IAQUINTA

Emblemata 51

Scholastica 54

Watercolors 80

Bookplates 96

Convex and Concave 130

The Compass Card 137
SALVATORE IAQUINTA

Three Worlds 140

Biographical Timeline 170

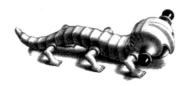

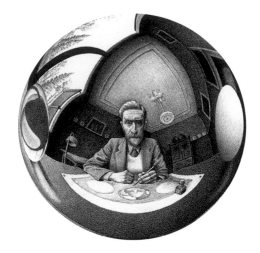

Explanation of Annotations and Inventory Numbers

Escher retained virtually all of his unique work (drawings, watercolors, printing plates and constructed objects) throughout his lifetime. These art works were transferred by him to the M.C. Escher Stichting, a family foundation, during the years 1969, 1971, and 1972. The Stichting, in turn, loaned this material to the Hague Museum. On the verso of each drawing and watercolor is written in pencil the "T" inventory number under which it was catalogued by the museum at the time of the loan. With just a few exceptions, each drawing was microfiched by Inter Documentation Company of Zug, Switzerland, and is illustrated in the microfiche set entitled *M.C. Escher: The authentic collection of all Escher drawings from the Gemeentemuseum The Hague on microfiche.*

Escher's original prints (lithographs, woodcuts, and mezzotints) were catalogued by F.H. Bool and published in *M.C. Escher: His Life and Complete Graphic Work*. This is the reason why each work of art in this show has a B (Bool) notation, except for the two prints which were not known by Bool. One of these is included in the exhibition. In the case of drawings and watercolors, the microfiche number is provided whenever possible. Lastly, all measurements within the catalogue are in inches.

References

Bruno Ernst, *The Magic Mirror of M.C. Escher*, Taschen 1978.

M.C. Escher, *Escher on Escher: Exploring the Infinite*, Abrams 1986.

M.C. Escher, *M.C. Escher: The Graphic Work*, Taschen 1992.

J.L. Locher, *M.C. Escher: His Life and Graphic Work*, Abrams 1981.

Doris Schattschneider, *M.C. Escher: Visions of Symmetry*, Abrams 2004.

Acknowledgment

G E O R G E S . B O L G E

Executive Director, Boca Raton Museum of Art

M.C. Escher's work ethic, his prodigious draftsmanship, and his lifelong commitment to his inner vision of the universe are internationally admired by the curious novice as well as the professional artist and the theoretical mathematician. His remarkable visions, facilitated by his superb command of his craft, permitted him to treat reality like a piece of paper that could be cut, folded, shaped and rearranged in infinite combinations and permutations.

During his career, Escher was not given the accolades his extraordinary talent deserved from the Dutch Art establishment. His aesthetics were considered too old fashioned, his graphic work more craft than art, and his concepts too mathematical. In fact, in 1954, a presentation of his work at the Stedelijk Museum in Amsterdam was organized in conjunction with an international congress of mathematicians. In 1968, on the occasion of his 70th birthday, he received his first retrospective at the Gemeentemuseum.

In his famous images, Escher contrives a picture puzzle of thoughts and ideas which appear to the viewer as a two-dimensional surface which can evoke depth and height, convex and concave, inside and outside. The viewer must penetrate the logic of the vertical image in order to uncover something of true reality. However, he is confronted only with the limitation of his senses when he tries to focus on subject matter that is non-existent.

This exhibition, *The Magical World of M.C. Escher* is the most comprehensive examination of this artist's work organized in the United States and will be presented chronologically, supplemented and amplified by personal correspondence and documents, plans and designs, models, posters and other memorabilia. Without the cooperation of the M.C. Escher Foundation and its Chairman, Willem F. Veldhuysen, it would have been impossible to put together a presentation of this magnitude. Once again, the Boca Raton Museum of Art has benefitted from its association with Rock J. Walker, who has agreed to lend his personal collection, the second largest in private hands in the world, and to be the Guest Curator. In this capacity, he has coordinated all the details inherent in the production of this spectacular tribute to the genius of this artist.

The Museum is especially fortunate to have attracted the attention of entrepreneur Marc Bell, himself one of the premier collectors of the works of M.C. Escher, to this project. The loan of key pieces from his private collection and his enthusiastic support of this effort to organize the largest Escher show presented outside the Netherlands, has enriched both Escher scholarship and the Boca Raton Museum of Art's international reputation.

I want to thank the contributing essayists to the catalogue, Salvatore Iaquinta and Federico Giudiceandrea, who have worked diligently alongside Mr. Walker on this project from its inception.

Everyone associated with the organization of this show is extremely grateful to the following supporters who made its presentation possible: AT&T; Accrisoft; *Affluent*; The George and Frances Armour Foundation; Art Basel Miami Beach; *Arte al Dia International Magazine*; Bank of America; BankAtlantic Foundation; Black Design; Bloomingdale's; *Boca Raton Magazine*; Branch Banking & Trust Co.; Carlton Fields Attorneys at Law; Centre for the Arts at Mizner Park; Citibank, F.S.B.; *Coastal Living Magazine*; D & G Communications Group LLC; eComDat, Inc.; *Florida Travel+Life*; General Growth Properties, Inc. Mizner Park; Greenspoon Marder, P.A. Gulfshore Life Magazine; IBM Corporation; International Fine Art Expositions; La Kretz Family Fund; Lynn Financial Center; Marc Bell Capital Partners LLC; MDG Advertising, Inc.; Mellon Bank, N.A.; MetLife Foundation; Morgan Stanley; *Naples Daily News*; Neiman Marcus; *New Times Broward/Palm Beach*; *New York Times Magazine*; Nordstrom, Inc.; Northern Trust Bank of FL N.A.; Office Depot; Oxley Foundation; Palm Beach Show Group; *Sarasota Herald Tribune*; The Sidney, Milton and Leoma Simon Foundation; Sotheby's; South Florida Art Services, Inc.; *South Florida Sun-Sentinel*; Southeastern Printing; Target Stores; Thomas V. Siciliano, PA; UBS Financial Services, Inc.; Uncle Julio's Fine Mexican Food; Wachovia Wealth Management; Wirespring Technologies, Inc.; WLRN Public Radio; WPTV NewsChannel 5; WXEL–TV/FM; Yellow Book; with additional funding provided by grants from the City of Boca Raton; Palm Beach County Tourist Development Council; Palm Beach County Board of County Commissioners; Palm Beach County Cultural Council; State of Florida, Department of State, Division of Cultural Affairs; Florida Arts Council; National Endowment for the Arts.

I especially would like to acknowledge the efforts of my staff in marketing, researching and installing a show of this scale and complexity. Finally, our Museum's Board of Trustees, led by President Paul Carman, should be recognized for supporting its staff's ability to provide for the benefit of this community a diverse and internationally respected exhibition schedule.

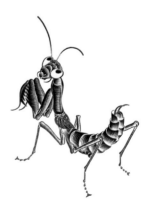

The Magical Work of M.C. Escher

W I L L E M F . V E L D H U Y S E N

Chairman, M.C. Escher Foundation

The Dutch graphic artist Maurits Cornelis Escher (Mauk to his friends) was born on June 17, 1898 in an impressive historic house known as "The Princessehof" in Leeuwarden, the capital of Friesland, a province in the northern part of the Netherlands.

He attended a secondary school in Arnhem, the city where he spent most of his youth. Mauk had difficulty in keeping up with the class and his marks (even in mathematics!) were not very good. What he liked most of all was drawing. His art teacher took an interest in him and taught him to make prints, especially woodcuts.

Mauk's parents wanted him to choose a respectable profession. A career in architecture seemed very suitable in view of his talents, so he started to attend courses at the Higher Technical School in Delft. Because he had failed his final examination at secondary school, he was not entitled to continue his studies in Delft. In order that he might gain some practical experience in architecture, his father advised him to go to the School of Architecture and Decorative Arts in Haarlem, where he studied from 1919 until 1922. It was there that he met the Dutch artist Samuel Jessurun de Mesquita, who became his teacher in drawing and graphic arts. De Mesquita taught him the many intricate aspects involved in mastering the woodcut technique and encouraged him to experiment on his own. Escher focused entirely on the graphic and decorative arts, particularly woodcuts.

After finishing his studies, Escher travelled extensively. He went to southern Spain, where he visited the beautiful Alhambra, a thirteenth to fourteenth century Moorish palace in Granada, and was greatly impressed and inspired by the geometric patterns of the Majolica tiles and stucco designs which decorate these buildings.

Italy – An Inspiring Country

Italy fascinated Escher more than other countries. Early in 1923 he stayed in a hotel in Ravello where he met a girl named Jetta Umiker, the daughter of a Swiss industrialist who had lived in Russia for twenty years. A year later, in 1924, he married Jetta in Viareggio (Tuscany).

The couple decided to move to Rome and lived there between 1923 and 1935. Every spring Escher would travel throughout the countryside. He visited the Viterbo area, Abruzzi, the island of Corsica, the towns of Calabria, the Amalfi coast and Sicily. On these journeys he recorded on paper whatever interested him. Upon his return in the winter his best drawings and ideas were worked out in prints.

The rise of Fascism made the Eschers' lives in Italy less congenial so they moved to Switzerland in 1935 and two years later they moved to Ukkel. Escher settled in Baarn, a small lovely town in the center of Holland. In 1970 he moved to Laren, where he lived in a home for retired artists. He suffered from health problems throughout most of his life.

During his last trip abroad to study in 1936 he returned to the Alhambra. This second visit was the starting point of a complete change in styles and themes. The Moorish interlocking geometric designs, which for religious reasons show a total absence of any human or animal form, strongly influenced his work. In principle, these designs could continue to infinity. Escher wanted to bring these abstract design patterns to life by utilizing animals, plants and people as design elements since the impact of something recognizable would enhance his compositions. His stay at the Alhambra and his eventual departure from Italy both contributed to the new direction in his work. To his way of thinking the landscapes of Switzerland, Belgium and Holland were less striking than those in southern Italy and Tuscany. This change in his style resulted in two periods of his oeuvre – the work done before and after 1937. Maurits Cornelis Escher died on March 27, 1972, and was buried in Baarn.

In this exhibition, the beginning of his career is represented by works of visible reality – drawings, woodcuts and lithographs of Italian landscapes as well as the architecture of Italian cities and towns. Viewing this presentation is like experiencing Escher's artistic life, viewing compositions inspired by travels and forms.

Creating in his own studio

After 1937, Escher travelled only as a tourist. His artworks were created and printed in isolation in his studio. He no longer drew his inspiration from the world around him. Instead, he depended on the inventiveness of his own imagination. These images explored the regular divisions of the plane, limitless space, rings and spirals in space, mirror images, inversions, polyhedrons, relativities, the conflict between the flat and the spatial, and impossible constructions.

Escher excelled in portraying pure geometry. Occasionally, during the early years, he experimented in this direction, but only now did the ideas take shape. He felt that until then he had merely been doing facile printmaking. Escher had become world famous for his unusual draftsmanship and his technical achievement as evinced in his lithographs and woodcuts. In his work, his keen observations of reality and the expression of his own fantasies can be recognized and observed in his extraordinary manipulations of space, time and perspective, rearranged according to his own ingenious logic. Viewers of this show will observe simultaneity of perspective is commonplace, infinity is approachable, and the positive and negative are interchangeable.

The M.C. Escher Foundation

In 1969, Escher established The M.C. Escher Foundation. The objective of the Foundation was to control his artistic inheritance, publish books about his work, and organize exhibitions of his work. Currently, the M.C. Escher Foundation, whose honorary Chairman is George A. Escher, the eldest son of the artist, promotes exhibitions all over the world, publishes books, and supports scholarship and research. The Foundation's main objective is to familiarize the public with the work of M.C. Escher. To this end, it enthusiastically supports this exhibition at the Boca Raton Museum of Art. The collection of Rock J. Walker, which is showcased in this exhibition will afford all those who view it the opportunity to examine the ingenious, mystical, magical and innovative oeuvre of M.C. Escher.

Filling the Void

BY FEDERICO GIUDICEANDREA

In 1957, Maurits Cornelis Escher was commissioned by the De Roos Foundation to write a book on the regular division of the plane. Those who were aware of his oeuvre also were aware of the large body of work that the Dutch artist had dedicated to investigating these questions. This commission gave Escher an opportunity to put forth several theories which he already had formulated during the course of producing his graphic works. The result is a long article with six key areas.

His experience as an illustrator helped Escher to postulate the problem. As he wrote, "a flat surface that is regarded as unlimited on all sides can be filled with, or even subdivided by, similar geometric figures that border each other on all sides without leaving any empty gaps." We will return to these empty gaps later.

Even before being asked to do this project, Escher had developed approximately 101 tables of examples[1] of these regular figures –figures that fill an area and that are all based on regular, geometric forms that border each other in repeated patterns. During a visit to the Alhambra (Granada), he had the opportunity to collect examples of motifs that represent an extensive repertoire of geometric figures used by the decorative artists who worked on the building. The Arab craftsmen had to restrict themselves to a limited selection of forms for decorating surface areas since their religion prohibited figurative illustrations (Fig.1).

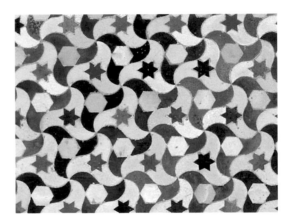

Fig. 1 **Mosaic in the Alhambra**

Interest in the regular (or periodic) subdivision of surface areas is much older than this exemplar. The first attempts date back to the time of the Ancient Egyptians as seen in the tomb frescoes located in the Valley of the Kings. The first European artist who filled surface areas with non-geometric figures was Koloman Moser[2] (1868-1918), one of the founders of the Vienna Secession. He dedicated a great deal of his creative efforts to applied arts and took particular interest in the production of fabrics and posters as well as decorative glass. He designed fish patterns for filling surface areas. (Fig. 2)

Fig. 2 **Filler by Koloman Mose**

5

[1] Escher created over 130 symmetry drawings during his life, but only 101 prior to 1957 according to *Visions of Symmetry*.

[2] Koloman Moser (1869 – 1918) worked on the publication of the magazine Ver Sacrum, the official publication of the Vienna Secession. In various editions, he published periodical area fillers based on natural elements, which were designed as elements for wallpaper.

There are a total of 17 ways of filling a flat surface with regular patterns. These figures, also known as wallpaper groups (Fig. 3), are essentially based on transformations that can be configured to fill a single plane. They also are referred to as isometries since they leave both the size and the form of the figures themselves unchanged. These isometries are divided into three categories – displacement, rotation and reflection[3]. The reason there are just 17 ways of filling a flat surface with figures that are subject to isometric transformations was explained by Fedorov, Schoenflies and Barlow in 1891 using the algebraic group theory which had been developed in 1832 by the young French mathematician Evariste Galois[4].

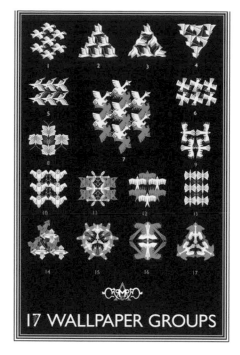

Fig. 3 **17 Wallpaper Groups**

It is important to mention at this point that the number of ways in which an area can be filled without any empty gaps using basic figures by means of displacement, rotation or reflection is exactly 17, i.e. a finite number. Similarly, the number of possible "fillers" of a three-dimension space with solid bodies subject to isometries also is limited even though there are 230 methods of achieving this result. This knowledge was demonstrated by the crystallographer Evgraf S. Fedorov in 1890.

The issue of the subdivision of the general n-dimension space was presented by Hilbert during the famous second International Congress of Mathematicians held in Paris in 1900. He proposed 23 unanswered problems[5] which later generations of researchers forged into the history of modern mathematics. In 1920, Ludwig Bieberbach proved that the regular sub-division of all spaces with arbitrary dimensions using isometric transformations was limited[6]. In the language of mathematicians, this means that the number of spatial groups of any arbitrary size is limited.

These conclusions are surprising since they tell us that the reality that we describe as space cannot be filled arbitrarily with the same forms or split into elements of the first order but can, in fact, only be filled with very specific forms. Space itself, therefore, appears to be subject to a law which governs its structure.

[3] Expressed using mathematical terminology, An isometry is a combination of displacements and reflections along lines (vertical or horizontal) and rotations around a point (for example one can get from 'd' to 'p' by means of a 180° rotation. To get to 'd' from 'b' for example by means of a reflection along a vertical line and from 'b' to 'p' by reflection along a horizontal line). Plane filling is isohedral if an isometry exists between two specific arbitrary filling elements in which one of the two elements is transformed into the other, but the plane filling remains globally unchanged.

[4] Evariste Galois (1811-1832), a wonder boy and genius mathematician with a fiery character, was expelled from the Ecole Normale and arrested twice as a result of his active Republican militancy. He died during a duel. Guessing that he would not survive the duel, he decided to finish his mathematical work the night before. There are notes in these last documents where he states that he no longer has the time required to make a final illustration. That night he completed the algebraic group theory for the description of permutation groups in the solution of a defined polynomial.

[5] This question was posed by Hilbert in the first part of his 18th problem – is there a limited number of space groups for every multi-dimensional space which fills the space without gaps by means of isomorphic transformations? In the second part Hilbert asked how one could fill the space with spheres so that the empty gaps could be minimized. This problem, which appears simple at first glance, turned out to be extremely difficult to prove. It was not until 1998 that Hales found a computer-based proof which is currently being examined by the world of mathematics.

[6] The number of space groups in a four-dimensional space is limited to 4783.

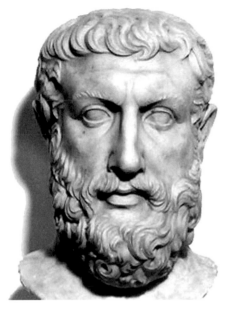

Fig. 5 **Parmenides of Elea**

Let us now return to the empty gaps mentioned at the beginning of this discussion, which Escher recognized as the primary task confronting him. As we have said, regular figures can fill an area without leaving any gaps. This task is reminiscent of one of the most important texts of philosophy and Western culture – the work "On Nature" by Parmenides of Elea[7], who lived between ca. 540 and ca. 470 BC. The section that refers to this discussion reads, "[…] by being it is", a thesis that is not easy to interpret and has offered philosophers matter for debate for generations.

Parmenides was concerned only with being, i.e. what the world is and how it is. Our senses tell us that the world is a space in which bodies and gaps alternate. This can be demonstrated by the movement that we all experience when we follow a body which takes up parts of a space by moving through a void. According to Parmenides, our senses and experience do not give us an accurate account of what transpired. Only our mind can give us an accurate assessment of what happened. Parmenides had attended the School of Pythagoras. Some claim that he was a pupil of Pythagoras' follower Amina; others (including Plato and Aristotle) believed he followed Xenophanes. Pythagoras had proven the incomparability of the diagonals with the side of a square[8]. This discovery disproved Pythagoras's belief that everything could be described with integers by means of relations. This discovery was kept secret, however, so as not to interfere with the belief of the then Greek world in the conformity of the sensory world with the world of reason.

It was this finding specifically that these two worlds do not necessarily have to be identical, that Parmenides used in order to develop his thesis which stated – that only being is, the not-being can not be. This philosophical principle was developed using the Elenchus, as proposed by Karl Popper[9]:

i) Only being is (only what is, is)

ii) The nothing, the non-being, cannot be.

iii) The not-being would be the absence of being: it would be the void.

iv) There can be no void.

v) The word is full: a block.

vi) Movement is impossible.

7 Parmenides was a pre-Socratic philosopher from Elea, a Greek colony on the coast of Campania to the south of Paestum. According to the tradition of Plato, Parmenides was born between 515 and 510 BC; using the chronology of Apollodorus provided by Diogenes Laertius, he was born around 540 BC. As a pupil of Pythagoras's school he was the founder of the School of Elea where he taught Zeno. His teachings are recorded in a didactic poem which traditionally bore the title "On Nature".

8 Pythagoras's theorem shows that it is impossible to divide the diagonals of a square into a certain number of identical sub-units so that they are also sub-units of the side. The diagonals and the corresponding sides cannot be placed in a numerical relation that can be described by an integer.

9 Karl Popper (1902 -1994), epistemologist, born in Vienna, is one of the leading philosophers of the 20th century. Poppers Elenchus is taken from his essay "How the Moon might shed some of her light upon the Two Way of Parmenides (I)", which was published in the "World of Parmenides Essays on the Pre-Socratic Enlightenment" 1998 by Routledge, New York.

7

The phenomena that we perceive through our senses are, according to the revolutionary view of Parmenides, delusional apparitions. The world is a full space, single and immobile, without time.

Since this excursion into Parmenides' ontology concludes that "only what is, is"; or rather "The world is full," therefore, Escher's mission would be to fill an area or a volume with regular forms without leaving any gaps.

Is Parmenides therefore illustrated by Escher? This is not a simple matter to explain. More accurately the philosopher and the artist appear to be accepting the same challenge –the former with his mind attempting to explain the world on the basis of an assumption, the latter with geometric figures in combinations. Science and art, which also are regarded as different activities and languages of the human being, often study the same objects and have common forms of illustration.

If we assume that the world is full, we are then confronted with the question of the properties and

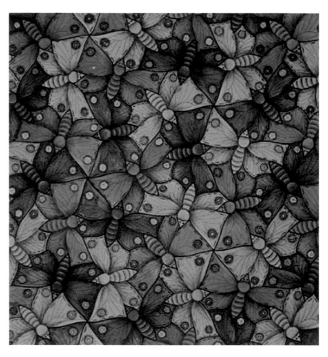

Fig. 6 **Study of a regular division of area with butterflies**

arrangement of the atoms that make up the world. By atoms we mean those primordial elements that compose the world. It is primordial because, in the view of the two pre-Socratic philosophers, Leucippus and Democritus[10], it can no longer be divided (a-tom from the Greek "cut", with the "a" at the beginning meaning division is impossible). We already know that there are limited ways of arranging the elements. And for this reason we assume that Escher's fillers somehow reflect the being of space and time itself.

This assumption reinforces our view that in its search for the original elements from which all matter is composed, modern particle physics uses the same algebraic formulae used by crystallographers to show that the wallpaper group is complete. The search for elements that retain their properties during transformations is the basis of modern theoretical physics[11]. In addition, the recasts of the filled areas, which Escher called, illustrated metamorphoses (primarily in works such as Verbum (Bolo 320), Metamorphosis II (Bolo 326) or in his masterpiece Metamorphosis III (Bolo 446) suggest Parmenides' complete worlds with no gaps and in constant transformation.

[10] Leucippus (5th century BC) was a pre-Socratic philosopher and his pupil Democritus, a philosopher in the Eleatic Tradition who taught about an element that could not be split, the atom, the final original particle of matter, in an attempt to solve Zeno's paradox of infinite splitting.

[11] The standard model in particle physics is a theory that describes three of the four fundamental forces, strong nuclear interaction, electromagnetism and weak nuclear interaction (the latter two combined in weak electrical interaction) and the function and properties of all known and observed elementary particles from which matter is made. This is a quantum field theory based on the group theory which agrees with both quantum mechanics and with the special theory of relativity. The behavior of the elementary particles can generally be described precisely by a unitary group, known as the Gauge Group. The Gauge Group of strong interaction is called SU(3) while the electric weak interaction is known as SU(2)xSU (1). Therefore the standard model is also known as SU(3)xSU(2)xU(1). The gravitons, the elementary particles that are assumed to provide gravity, are not taken into account in the standard model. The group theory which also takes account of gravitons is known as SU(5) or the theory of the whole. This is still waiting for confirmation and acknowledgement by the world of physics.

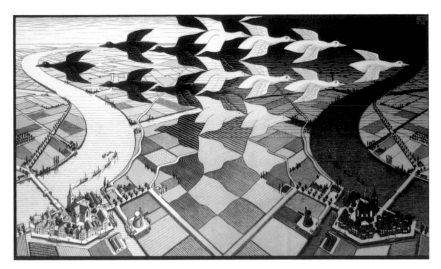

Fig. 7 **Day and Night**

Seeing change as a continuous transition between one filler and another suggests a possible solution of the illustration of time as another coordinate of space. Albert Einstein describes in his Theory of Relativity the space-time continuum is regarded as something continuous and time is regarded as a supplementary dimension to the three spatial dimensions (top – bottom, right – left, front – rear).

A point moving in space is shown as a track in the space-time continuum. It is as if each moment already was shown on a three-dimensional strip of film. In this space-time continuum it is possible for four-dimensional atoms to fill everything without gaps – and without preventing movement, therefore solving the paradox of Parmenides.

This interpretation even pleased Albert Einstein, who declared himself a supporter of Parmenides. He had an opportunity to do so in a discussion with Karl Popper. Einstein suggested "that the world is a four-dimensional Parmenedian block universe in which change was a human illusion, or very nearly so." Popper remembers, "He agreed that this had been his view, and while discussing it, I called him Parmenides."[12]

By the time of his death in 1972, Escher had produced a series of important works based on the division of area and space. He had explored 16 of the 17 symmetrical groups[13]. During this phase of his work, he developed different prints mainly depicting contradictory concepts such as day and night, earth and sky (fig. 7), and good and evil (fig. 8). These images filled our world without gaps like atoms, and will forever be treasured in the history of graphic art.

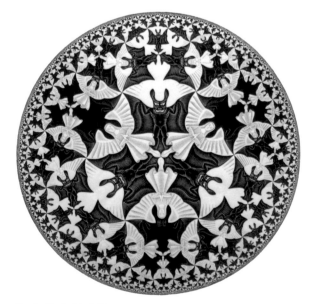

Fig. 8 **Circle Limit IV**

[12] See K. Popper, "Unended Quest, an Intellectual Autobiography", Open Court Paperback 1985, page 129

[13] See Doris Schnattschneider, "M.C Escher: Visions of Symmetry", Harry N. Abrams Inc. Publishers, 2004, page 325

The Reluctant Pop Culture Phenom

BY SALVATORE IAQUINTA

*… I am most eager to reproduce one of your works on the cover-sleeve…You might even like to do a long one like "Metamorphosis" which we could then reproduce as a folding-out sleeve.** – Mick Jagger

M.C. Escher's popularity is as strong as ever. Images adorn T-shirts, mugs, and posters. Movies, television, and music all make references to his topsy-turvy world.

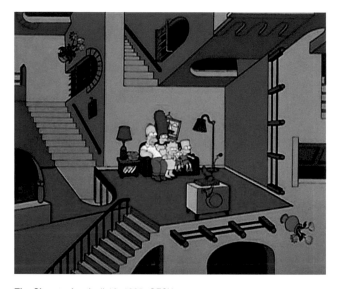

The Simpson's - April 16, 1995, ©FOX
The characters entered the living room from odd staircases akin to "Relativity."

We live in a world where we are constantly bombarded by what is "hot." We have seen more than we wanted on television and the internet from people of all walks of life, from suburbanites to multimillionaire moguls, doing just about anything and everything for attention. We have grown so accustomed to brash and bawdy behavior that we accept it without surprise or question. But Mr. Escher would have been appalled at a British artist's confession that his best "spot" paintings were done by his assistants.

The phrase "sell out" might have originated in the music industry, but it has spread to all forms of art and entertainment. Selling out, in essence, is to accept money to stop following your principles. For music, selling out might be to make the trendy music the record companies want a musician to make, rather than the musician creating the songs he wants to make. In art, selling out might best be summed up by the Damien Hirst statement, "I can't wait to get into a position to make really bad art and get away with it." What does this have to do with M.C. Escher? Everything and nothing. Nothing, because you do not need to know the man—not even his name— to enjoy the woodcuts and lithographs on the wall. Everything, because when you learn about the man you discover why it is so rare to see an original Escher creation.

Much has already been said about his creative techniques. Mathematicians and computers can explain all of his tessellation patterns and architectural curiosities. Those stories are easy to tell; they come from the artworks themselves. But little has been said about M.C. Escher himself. The prints have outlived the artist, and we have to look elsewhere for answers to questions never asked. His friend and business advisor, J.W. Vermeulen, wrote a biography of Escher, and Escher left behind many diaries. Escher's popularity didn't spike until the 1960s, when Escher himself was in his sixties. His reply to the sudden interest in his artwork loosely translates as, "I walk around in mysteries. Each time, youngsters say: you make Op-art too. I don't know what that is, Op-art. This work I have been making for the past thirty years." His statement is true since he created *Sky and Water* in 1938.

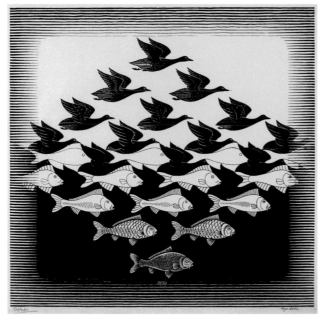

Sky and Water, 1938

Escher struggled for years to make a living as an artist. Why didn't he follow Dali or Vasarely? They were putting out lithographs, etchings, and screen prints by the thousands to meet demand. A woodblock can be printed by a printing press. A hundred black and white prints could be produced in minutes. Escher's friend, Bruno Ernst, said that Escher himself thought that he did "mass production." The woodcut is a medium that allows for more than one original to be produced. According to Ernst, Escher preferred hand printing because he could control the intensity of the black. Escher remained in control of every piece he printed. He often annotated the block prints with "eigen druk" which loosely translates as "printed by my own hand." Escher's annotation deliberately informed collectors that they were buying *his* work.

Dream was an early print that found new life in the sixties. Escher carved the block in 1935, but reprinted it in the 1960s. The later prints show an extra white line in them where the block started to crack. While Escher spent his time printing his blocks by hand as needed, someone made a blacklight poster of *Dream* for the masses.

What did Escher say about the illegal posters? Vermeulen writes "(Escher) would jump to his feet when people showed interest and wanted to know more. After examining reproductions, produced illegally by shady characters, that most often did not leave anything of the original sophisticated detail, he let go with a derisive remark such as: Whoever is not against me is for me, or something to that effect."

Vermeulen implies that Escher was not against reproduction of his art. But that nonchalant attitude is not entirely consistent with history. The "Holland Herald," (Vol 9, No.1, 1974) featured an article about Escher declining Mick Jagger's request to use an Escher image for an album cover! In 1969, Escher received a letter from Mick Jagger that began with "Dear Maurits." Mick conveyed his appreciation for Escher's artwork and offered suggestions as to which pieces (*Verbum* or *Metamorphosis*) would be ideal for a record jacket. Escher appeared slightly peeved in his response, closing with "By the way, please tell Mr. Jagger I am no Maurits to him, but Very Sincerely, M.C. Escher.

However, Escher alludes to something else earlier in the letter. He states "I cannot possibly accept any further

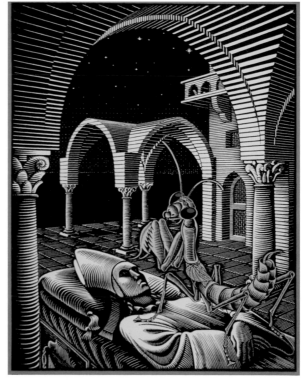

Dream – Blacklight Poster, 1960s

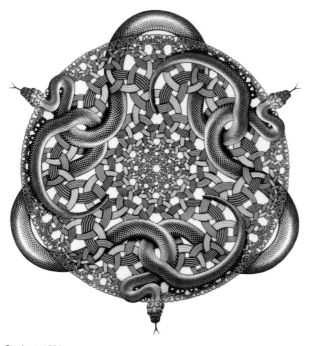

Snakes, 1969

assignments or spend any time on publicity." Was it because he was unhealthy? In 1969, he finished his final woodcut, *Snakes*. Escher reportedly feared not being able to finish this final print before he died. He lived another few years, only managing to print older pieces because carving blocks took too much energy. He wrote to his lifelong friend, Bastiaan Kist, that he was "not afraid of death – if it happens without pain." There is a touch of irony to an artist not fearing death, but fearing dying before finishing his final masterpiece, especially when that piece is arguably a metaphor for eternity.

Maybe it was the time other endeavors consumed, regardless of health. He loved his work, even as he aged. Escher's mind remained fertile into his seventies. Whereas many famous artists of the 20th century are renowned for the pieces they created in their twenties and thirties, a number of Escher's most famous creations were produced during his seventh decade. From a creativity standpoint, Escher died at the same age and time as Jimi Hendrix…fans are left dreaming *what could have been* if only he lived longer.

Escher received a letter of apology and a renewed offer from The Rolling Stones. He declined once again. He wrote "I can't give permission to reproduce my prints for the record covers and suchlike. It is not that I am offended by your previous letter, but I can't make - in all fairness to many other requests - any exception to this rule."

But what is the rule? Does it have something to do with the beauty of original art? Escher revealed his thoughts of the art movement of the sixties when he wrote: "To tell you the truth, I am rather perplexed by the concept of "art". What one person considers to be "art" is often not "art" to another. "Beautiful" and "ugly" are old-fashioned concepts that are seldom applied these days; perhaps justifiably, who knows? Something repulsive, which gives you a moral hangover, and hurts your ears or eyes, may well be art. Only "kitsch" is not art - we're all agreed about that. Indeed, but what is "'kitsch"? If only I knew!" Perhaps he feared becoming kitschy.

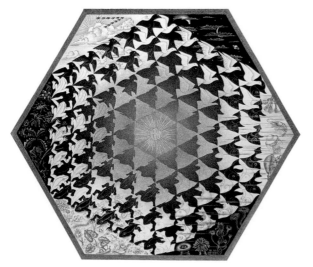

Verbum, 1942

Beautiful might be an old-fashioned concept, but it remains applicable here. The original prints *are* more beautiful than the reproductions. The detail is often lost in the poster versions. The glossy pages of books can't convey the softness of the Japanese paper. Most copies are done on bright white paper, a medium rarely used by Escher. The soft cream paper softens the contrasts of his prints. The smooth, rich black of printer's ink surrounding *Dragon* is lost when reproduced. Would shrinking down and plastering *Verbum* on a glossy album cover add anything to the artwork? No. It could only add to the artist.

However, Escher did not need to promote himself. Vermeulen writes, "[Escher] asked himself sometimes: "Why do I continue to do that tedious reprinting? For more money? A fatter bank account can not contribute to your happiness in any way. To have more money than you have already does not make you less afraid, or more peaceful, or stronger or less sad in any way."

If Escher desired peace, strength, courage, and happiness above all else then it is understandable why he would not pursue fame and fortune. He complained that as his popularity grew he scarcely had time to work anymore. Fame decreased peace. And he was happiest in his solitary work. He wrote, "I've been doing this kind of work for over fifty years now, and nothing in this strange and frightening world seems more pleasant to me."

The 1960s were a chaotic decade, both inside and outside of the art world. People sought peace everywhere. In 1967, Escher wrote to his friend, Gerd Arntz, "The world in which we live is a hopeless case… I rather stay in abstractions, which do not have to do anything with the reality." Perhaps the sociopolitical events of the world stirred these feelings. Or, maybe the preceding decades in which he did not fit in conditioned him to step away from the stage once the world tried to welcome him onto it. Ironically, his "escape" from reality caught the real world's attention. In the end he left us with a unique universe that does what no sell-out ever does – makes us want more.

Thanks to Escher's friend Bruno Ernst, the author of *The Magic Mirror of M.C. Escher.* *Excerpt from the letter reprinted in The Holland Herald, 1974.*

13

A brief message:

The following catalogue is a brief analysis and retrospective of M.C. Escher's works. There are many other prints and drawings such as: *8 Heads* (right) that deserve specific mention. This extremely rare piece is only known to exist in a few copies. It is one of Escher's more visually complex tessellations. Few people recognize that there are eight faces in the mixture at first glance. Escher created *8 Heads* in 1922! He didn't create another tessellation woodcut until 1937, after which he never again took a hiatus. A cursory look through the following book might leave the impression that Escher's 1936 trip to the Alhambra inspired him to design his tilings, but the truth is that it merely unleashed the creative spirit already within him.

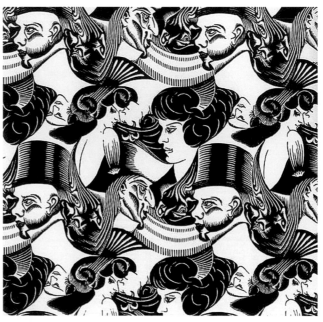

8 Heads, 1922

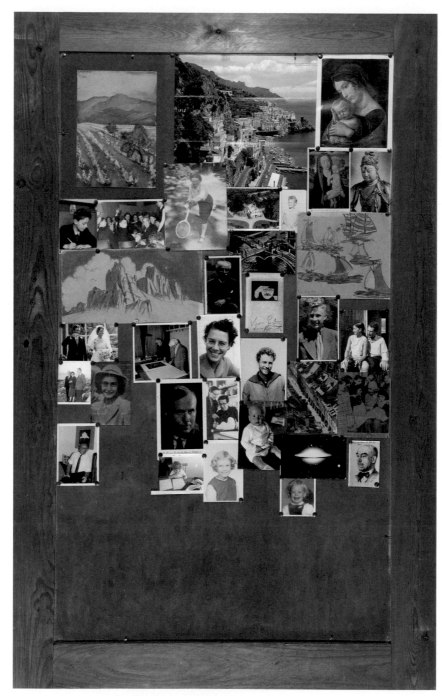

M.C. Escher's Tool Cabinet Door

This door is a biographical collage of Escher's life. There is a watercolor from Spain, a picture of the Italian coast, photos of his children, a photograph of G.H. 's-Gravesande (an art critic and friend), and even a small self-portrait of his teacher Samuel Jessurun de Mesquita (pictured below).

THE MAGICAL WORLD OF M. C. ESCHER PLATES 15

Winding Road, circa 1920, chalk, 13" x 16 1/2"
T210-x-1972, microfiche 1534

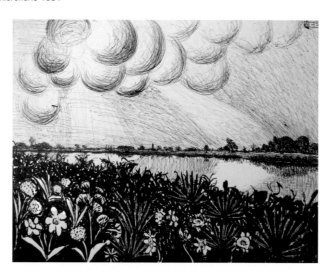

River landscape, circa 1920, ink, 18 1/4" x 24"
T688-x-1972, microfiche 1746

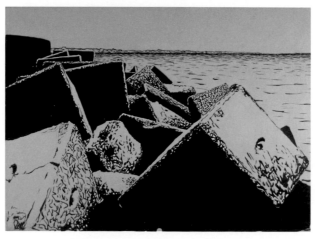

Boulders near the water (Basalt Rocks), circa 1920, ink, 13 1/4"
x 20 3/4" T220-x-1972, microfiche 1598

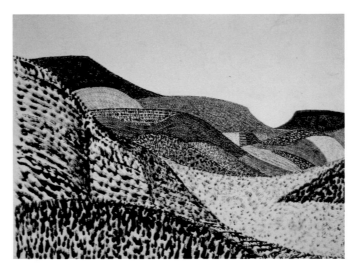

Hills, circa 1920, ink, 11 1/4" x 15"
T238-x-1972, microfiche 1545

Flowers, circa 1920, chalk, 15 3/4" x 12 3/4"
T213-x-1972, microfiche 1537

Lighthouse, circa 1920, ink, 16 1/4" x 21"
T203-x-1972

17

Nude, circa 1920, chalk, 19 1/4" x 25 1/4"
T207-x-1972, microfiche 1723

18

Fir tree, 1921, ink, 24" x 18"
T707-x-1972, microfiche 1764

Sunflowers, circa 1922, ink, 22 3/4" x 19 1/4"
T711-x-1972, microfiche 1768

The Borger Oak, 1919, linocut, 3 7/8" x 3 1/4"
B. 29

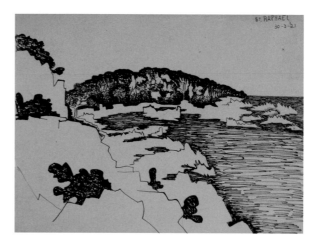

Coast near Saint Raphael, 1921, ink and pencil, 9" x 12"
T28-x-1972, microfiche 1554

20

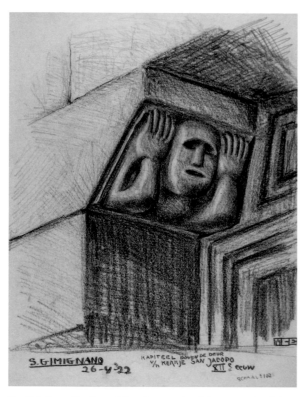

Capital above the door of San Jacopo, the 12th century church in
San Gimignano, 1922, chalk,10 7/16" x 9"
T740-x-1971, microfiche 449

San Pietro, Tuscania, 1924, ink and pencil, 12" x 15"
T107-x-1969, microfiche 1563

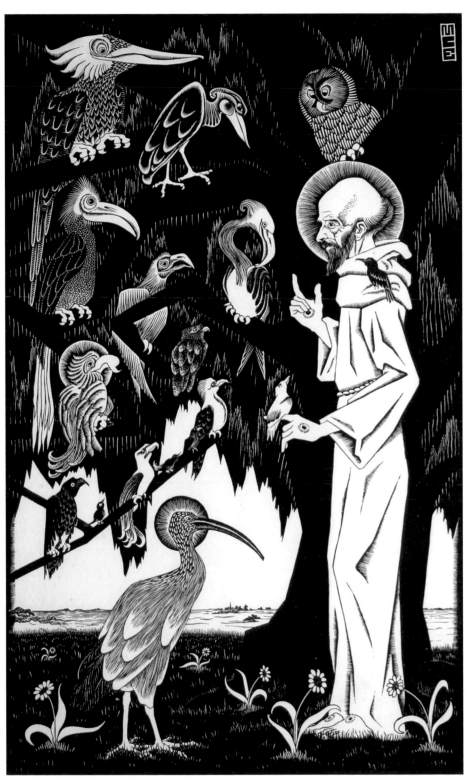

Saint Francis, 1922, woodcut, 20" x 12 1/8"
B. 89

21

Flor de Pascua

Escher created these woodcuts as illustrations for his his friend Aad van Stolk's booklet entitled *Flor de Pascua* (Flowers of Easter). These were made in 1921, when Escher was only 23 years old, they foreshadow future work.

Notice the first image, *Scapegoat*. It demonstrates the duality of black and white images and symmetry much like his tessellation pieces. *Fulfillment* is a precursor for *Fish and Waves* (page 164). *Sphere*, on the second page, is Escher's first spherical reflection self portrait. Escher made three more spherical self portraits during his life. Lastly, consider *Beautiful*, this symmetrically geometric print anticipates the circle limit pieces, notably *Circle Limit IV* (page 158).

Flor de Pascua suite with woodblock for Scapegoat, 4 3/4" by 3 1/2"
B. 69-83

Scapegoat

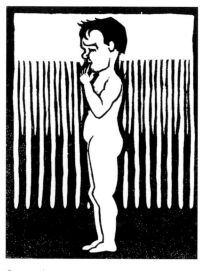

Convention

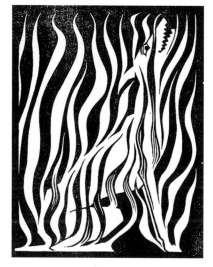

Fulfillment

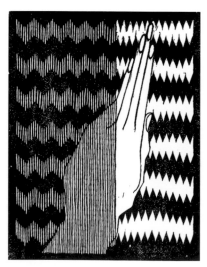

Madonna

Untitled

The Ghost

Pansy

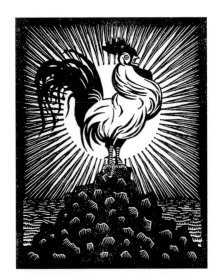

Theosophy

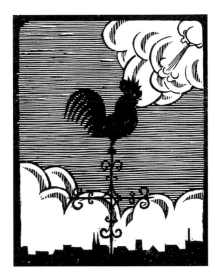

Weathercock

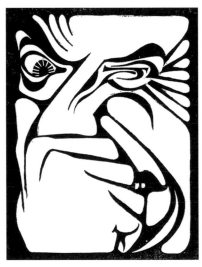

Perfume

Sphere

Superstition

Never Think Before You Act

Beautiful

Love

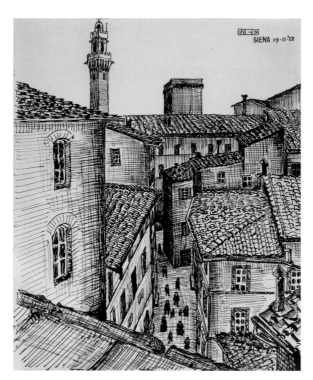

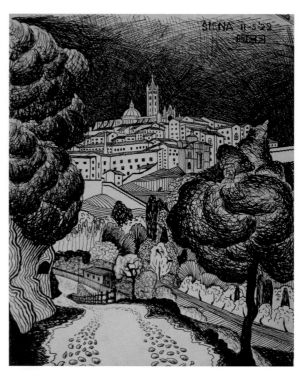

Siena, 1922, ink, 10 1/4" x 8/14"
T726-x-1971, microfiche 435

Siena, 1922, ink, 12" x 9"
T727-x-1971, microfiche 436

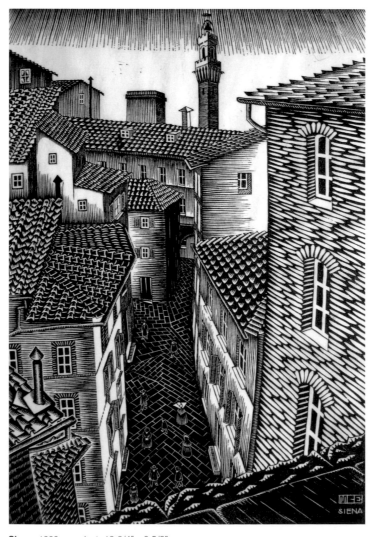

Siena, 1922, woodcut, 12 3/4" x 8 5/8"
B. 94

Dolphins in Phosphorescent Sea, 1923, woodcut, 11 1/2" x 19 3/8"
B. 97

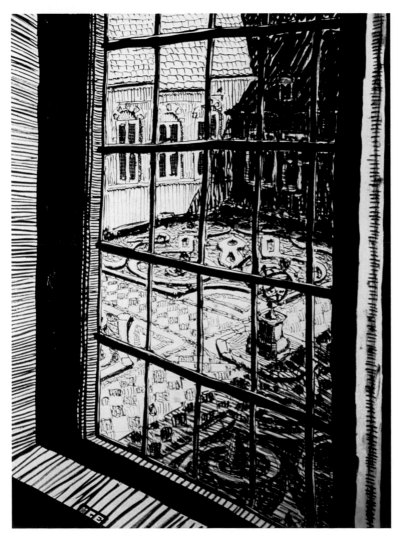

Window view onto courtyard, circa 1920, Ink, 21 7/8" by 16 3/8"
Microfiche 1736

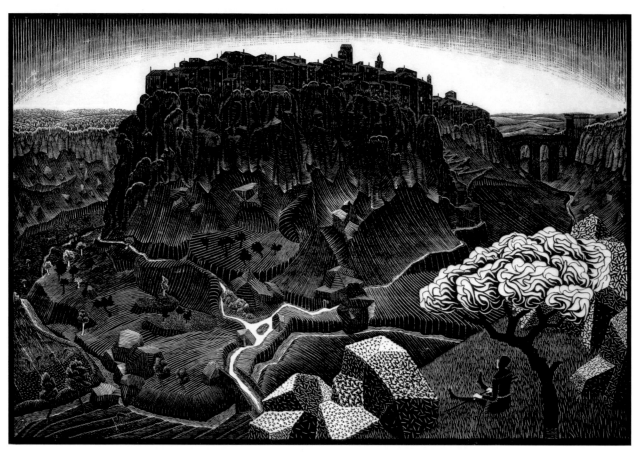

Vitorchiano, 1925, woodcut, 15 3/8" x 22 1/2"
B. 102

26

Ravello, 1925, ink, 15 1/2" x 20 1/4"
T115x-1969, microfiche 1569

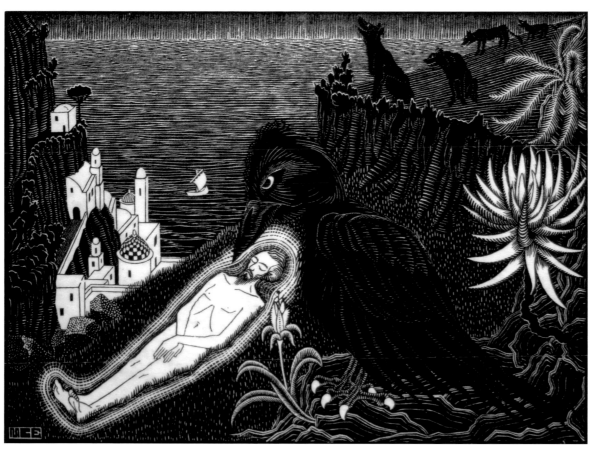

The Black Raven (St. Vincent Martyr), 1925, woodcut, 15 3/8" x 22 1/2"
B. 103

The Second Day of Creation, 1925, woodcut, 11" x 14 3/4"
B. 105

Column with grotesque figures, circa 1925, pencil, 12 5/16" x 11 7/16"
T289-x-1969, microfiche 1576

Vitorchiano, 1927, pencil, 20 1/2" x 19"
T179-x-1969, microfiche 1664

Ponte Di Cecco Astolipic, 1928, pencil, 19" x 26"
T189-x-1969, microfiche 1670

Madonna del Parto Sutri, 1927, chalk, 25 1/2" x 18 1/2"
T186-x-1969, microfiche 1667

Unfinished sketch of a hill town in Italy, chalk and pencil,
12 3/8" x 9 3/8"
T925-x-1971, microfiche 625

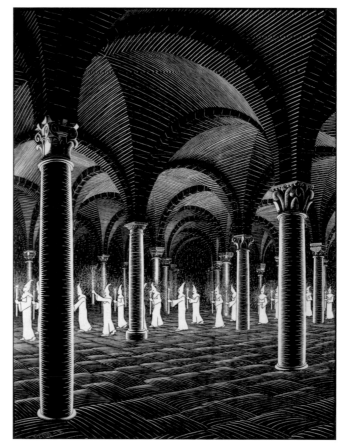

Procession in Crypt, 1927, woodcut, 23 3/4" x 17 3/8"
B. 115

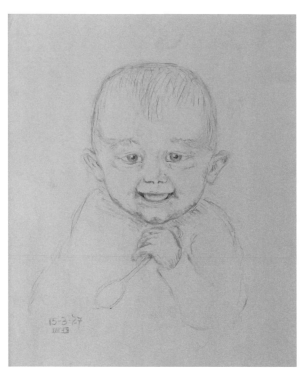

George A. Escher, oldest son of the artist, as a baby, 1927, chalk,
9 5/8" x 7 13/16" T248-x-1969, microfiche 1122

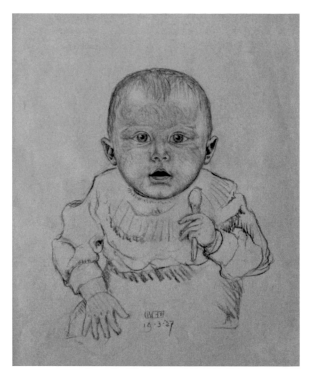

Baby, 1927, pencil, 17" x 14"
T246-x-1969, microfiche 1115

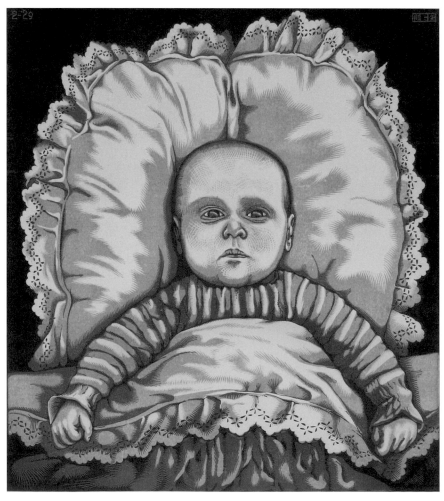

Infant, 1929, woodcut from three blocks, 16 1/8" by 14 3/8"
B. 125

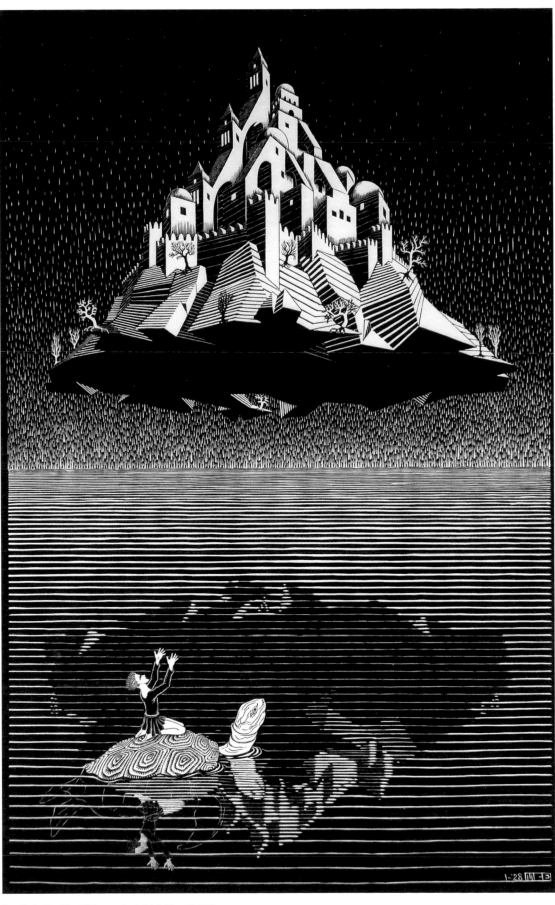

Castle in the Air, 1928, woodcut, 24 5/8" x 15 1/4"
B. 117

Escher Memories:
How Italy shaped the Future

BY SALVATORE IAQUINTA

M.C. Escher is best remembered for artwork that tickles the imagination. But even if he had stopped before creating tessellations and impossible buildings, his place in art history would have been secured by virtue of his images of cities and landscapes. This early work, neglected by the modern day public, was never forgotten by Escher. Elements of his years in Italy are woven into the creations we see every day on posters, calendars, and t-shirts.

Escher's later successes overshadowed the beauty and importance of his Italian period works. Some critics and curators have been reluctant to accept Escher as a great artist. His work is occasionally dismissed as computer graphic novelty. Never mind that his work pre-dates computers, the Op Art movement, or the psychedelic '60s by decades. The deceptive simplicity of tessellating fish implied the work was easily created. True, a wood engraving of cartoon fish is technically easier to carve than a landscape, but conceptually, many more hours of planning are needed to devise tiled fish than the landscape. The difficulty of devising a tessellation is highlighted by the fact that M.C. Escher, even when later adept and experienced, needed both silence and solitude to create one.

32

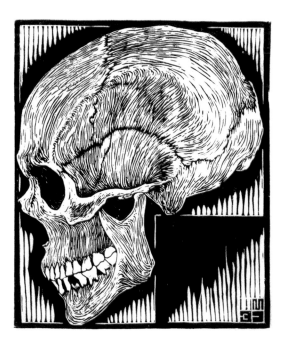

Skull, 1920

It is an Escher-like paradox that if he had continued as a realist, producing portraits and landscapes, he would likely be remembered as fondly as Rembrandt or Dürer in the art world. If the art world needs any proof that Escher is a legitimate master, they need to only look at the first half of his life. The Italian period not only stands by itself as an artistic accomplishment, but is the inspiration for future works.

Historians group Escher's life and work into four phases. The first is his early work, consisting of woodcuts and linocuts made as a student while in Haarlem. The artwork from this period is varied in theme. There are a number of portraits and even some drawings that hint at Cubism. Although he had been experimenting with linocuts, it was Samuel Jessurun de Mesquita, a graphics art teacher, who encouraged him to make this his field of study.

Examination of these prints demonstrates not only that he was learning to represent figures in black and white, but also that he developed the consummate techniques used to do so. One part of this process was to learn to think in reverse. Every image carved into a woodblock for printing must be carved in reverse, as though seen in a mirror. A closer look at *Skull* (ca. 1920) shows that he had not yet mastered that technique; the printing shows a reversed "CE" of MCE.

Colonnade, 1934

The second phase is referred to as the Italian period. Escher visited Italy in 1923, and lived there from 1924 to 1935. During those years he traveled extensively and created a large portfolio of drawings, lithographs, and wood engravings of Italian landscapes, seascapes, and buildings. About 40% of his life's work was created in those eleven years, including his largest lithographs. Escher's life is reminiscent of the plot of an old martial arts movie. He starts off as a young man in his hometown. He leaves for a far away land. There he studies, practices, and works hard. When he returns home he is a master and can do things that people have never seen before. In this case, instead of learning karate he mastered wood engraving.

The woodcuts of Rome at night are a lesson well learned. In *Trajan's Column* (page 66) all lines radiate from the center and in *Colonnade* all lines are diagonal, only their width varies. Two other night scenes were created by stippling the smooth wood surface. A fifth woodcut was produced entirely from small crosses of various widths.

Critics recognized his techinical achievements of this period. R.W.P de Vries wrote that Escher's "woodcuts have a dogmatic assurance". Another one commented that "Escher is a patient, precise, cool draughtsman." For example, the woodcut *San Giovanni* has a geometrical quality to it. It is not a picturesque representation of a beautiful church in Ravello; it is instead a calculated reproduction of arches and curves that is architecturally aesthetic. Closer inspection reveals that most of the print is merely a series

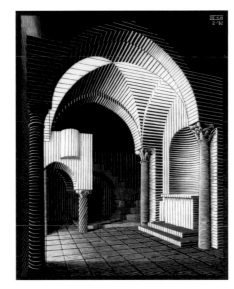

San Giovanni, 1932

33

of parallel lines, that when properly used, give the appearance of curves. The rigorous quality of the woodcut shows that Escher is ready to cross over into the art of mathematics. The rest of his life will be devoted to works that take more patience and deliberation.

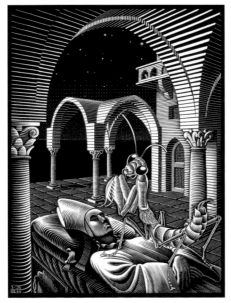

Dream, 1936

The third phase of Escher's work extended from ten to perhaps twenty years after he left Italy. During this time he focused less on representing the world as he saw it than on how it could be. One of the prints on the cusp of this transition is *Dream*. The subject is surreal. It depicts an oversized praying mantis standing on the casket of a deceased bishop somewhere in Italy. The arches and the style of the engraving were modeled after the woodcut *San Giovanni*. Soon after creating this woodcut Escher traveled to Spain. His trip to the Alhambra in 1936 influenced him profoundly and he soon devoted himself to the subject of tessellations. Although his work took a giant creative leap forward during this period, its importance was scarcely recognized in the art world.

The final period, from 1955 onward, has been dubbed "Recognition and Success." One would argue that commercial success should not be used when defining the phases of an artist's works. We should focus on the themes. After 1939, Escher completed only one cityscape, his first mezzotint. From then onward, his work is comprised of impossible architecture and objects, complex tilings of animals, and artistic renderings of geometric and mathematical constructs, i.e. what he became famous for. In fact, of his final 100 images, all the major pieces were fantastical except four. Three of the four involved reflection (*Dewdrop, Puddle,* and *Rippled Surface*), which might be viewed as studies on the geometry of reflections on different surfaces (round, flat, and rippled, respectively). The other major piece, his final mezzotint, was the still life of *Seashells* completed in 1949. *Seashells* could be considered a study of symmetries. In conclusion, even the artwork that appears 'simple' after 1939 was still a radical departure from the serene subjects of his Italian period.

The third and fourth phases may be combined into one, which I will term the period of spatial relationships. This term is purposefully vague. The pieces that fit into this category have a variety of subjects; perspective, reflection, conflicts of dimension, approaches to infinity, illusion, and the shape of space (curved around a Möbius strip or spiraling into infinity like *Print Gallery*). It encompasses both the studies of tessellations, and also the buildings where the normal rules of architecture and geometry are manipulated to create something that cannot be built. *Waterfall*, for instance, looks plausible at any single segment of the water's trough, but as a whole cannot exist. Innovative works like *Waterfall* were mesmerizing and increased Escher's popularity.

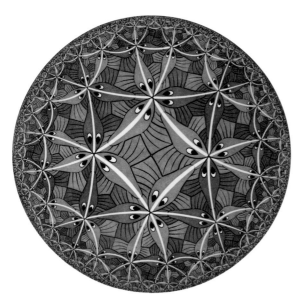

Waterfall, 1961

Circle Limit III, 1959

34

Although the public cannot be condemned for loving and immortalizing the fun creations of these years, anyone with an interest in the artist should take a moment to look further back in time. Scrutiny of Escher's famous works will show the borrowing of elements from earlier work. Although his life's work is not nearly as monotonously thematic as that of Salvador Dali (with melting clocks and crutches appearing everywhere), Escher never forgot his years in Italy when developing his imaginative masterpieces. The hints of Italy are what take his works from representations of mathematical constructs to beautiful works of art that would please the eye even without recognizing the "tricks." That is what made Escher famous. Few people can name the discoverer of hyperbolic geometry, but Escher's artistic representation of it (*Circle Limit III*) will forever remain in our collective consciousness.

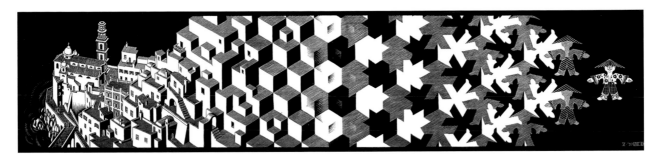

Metamorphosis I, 1937

The 1937 print *Metamorphosis I* demonstrates Escher's artistic transition from Italy to the imaginative world of the rest of his life. On the left is a coastal Italian city reminiscent of Atrani. It is done in the same style as his earlier Italian woodcuts and, in fact, was the subject of a nearly identical lithograph of Atrani. Unintentionally, Atrani represents his Italian past. As we move to the right, into the future, we see the world finally become more orderly and transformed into cubes. Escher's future work will become progressively more orderly. The cubes morph into two-dimensional hexagons. This transformation from three to two dimensions occurs repeatedly in his work over the following ten years (*Drawing Hands*, *Two Doric Columns*, and *Reptiles*). As we continue to the right the hexagons change into a tessellation of Asian men. It is almost as if Escher had the foresight to ease his audience into the adventure he would take them on over the next thirty-five years.

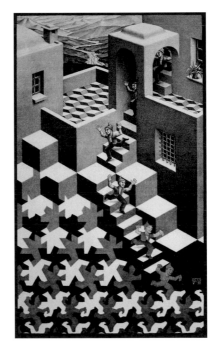

Cycle, 1938

When a year later he created *Cycle*, Escher's transition was complete. The tessellating figures becoming part of the building are the focus of the print. To add to the fantasy, even the bars on the windows are impossible to construct. Any single bar could be made, but the entire unit could not be assembled unless each bar was divisible into smaller pieces. Notice the background. Although he left Italy a few years before making this print, the Italian landscape looks like part of *Castrovalva*. The left side of *Metamorphosis I* and the top of *Cycle* also perform the function of adding quality to the simplicity of interlocked shapes. The tessellating tiles, while intriguing, appear to be children's cut-outs. The Italian element of the prints adds artistic legitimacy. Escher leaves no doubt that the creator of the tilings is also a skilled graphic artist.

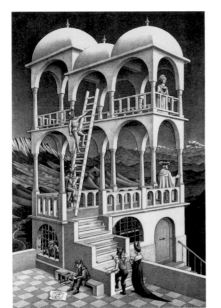

Belvedere, 1958

Jump forward twenty years to 1958. *Belvedere* must be in the same neighborhood as *Cycle*. The background is a similar valley in Abruzzi. The impossible crate the building is modeled after is seen in the hands of the seated figure on the lower left. Escher is almost teasing us. He was handed the wooden crate, but transformed it into a handsome building inhabited by Renaissance figures. Once again, he is adding quality to novelty. The piece contains a subtle reference to Hieronymus Bosch. In 1935 Escher created a

lithograph based on the theme of one of Bosch's paintings. The prisoner is trapped behind the same impracticable bars seen in *Cycle*. Escher continually reuses elements of this work.

Aloe plant, 1930

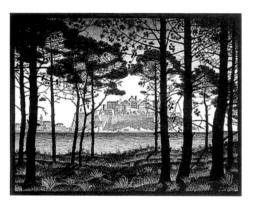

Pineta of Calvi, 1933

Waterfall (pictured previously) is set against another Italian backdrop. Perhaps these landscapes helped establish the otherworldliness of the subjects. Italian landscapes and stucco buildings were foreign to the average Netherlander in the 1940s and 50s. If that wasn't alien enough, the odd plants in the bottom left of *Waterfall* are actually enlarged mosses.

Other Italian flora (not magnified) show up throughout his later pieces. The aloe plant he drew in Tropea in 1930 (page 40) appeared soon after in woodcuts and lithographs (*Palm* and *Pentedatillo*). Fourteen years later a small aloe plant adorned the bottom left corner of *Reptiles*.

Likewise, palm trees appear throughout Escher's works. Perhaps he was attracted to their radial symmetry. He completed his first palm woodcut in 1923 (B. 98) during his first trip to Italy. He created another for *Emblemata* (B. 167) in 1931. The next one was in color in 1933 (B. 223). Lastly, in 1947, a palm tree is seen from two views in *High and Low* (B. 352).

The most subtle use of Italian vegetation is in *Puddle* (1952). The distinct trees reflected in that woodcut are the same trees in the foreground from the 1933 *Pineta of Calvi*. Notice the unique pods on the branches of the trees in both illustrations. Perhaps Escher was being self-referential, or just saving time by utilizing trees from old drawings. Regardless, it is a fragment of Italy interposed into a work many years after leaving the country.

Lastly, consider *Tetrahedral Planetoid*. The city planet does not seem that farfetched after seeing *Goriano Sicoli* (page 37). The hilltop city was the subject of his first lithograph (1929). The buildings are piled on top of one another almost like the stones of a pyramid. The city itself is an urban island surrounded by nature. Twenty-five years later, near the end of Escher's fascination with the platonic solids, he created a tetrahedron-shaped planet; a stacked city floating in space. Almost the same image can be created by reflecting *Goriano Sicoli* on itself.

Eleven years in Italy made a life long impression on Escher that surfaced repeatedly throughout his career. It is unknown if Escher was nostalgic or simply working with the drawings he had on hand. But either way, these subtleties prove one thing: you can take the artist out of Italy, but you can't take Italy out of the artist.

Tetrahedral Planetoid, 1954

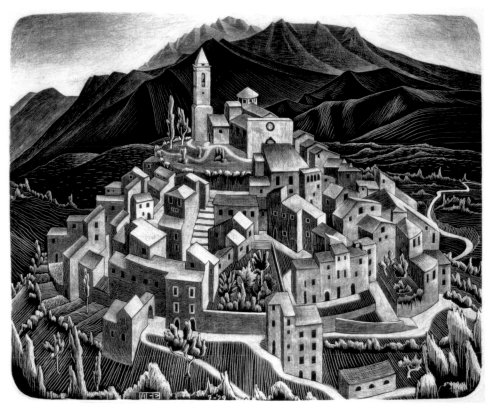

Goriano Sicoli, 1929, lithograph, 9 3/8" x 11 1/4"
B. 126

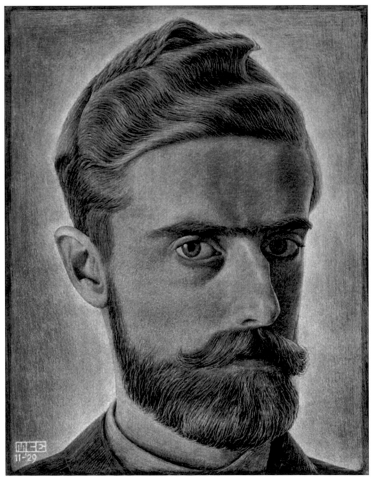

Self Portrait, 1929, lithograph, 10 3/8" x 8"
B. 128

Pescostanzo, 1929, pencil, 26" x 19"
T238-x-1969, microfiche 1693

Scanno, 1929, chalk, 19 3/8" x 26"
T225-x-1969, microfiche 1684

38

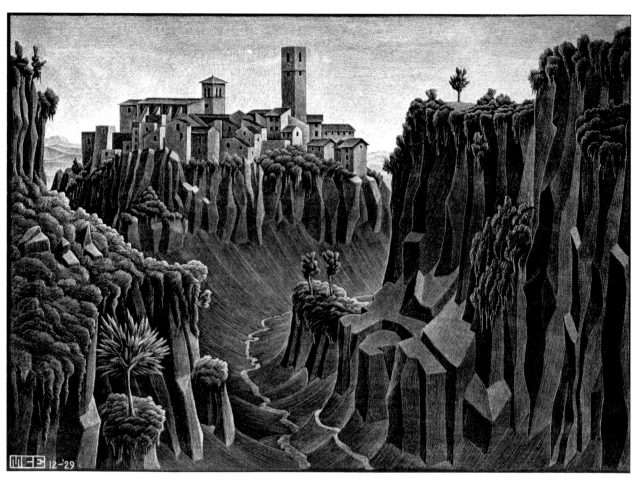

Barbarano, 1929, lithograph, 6 7/8" x 9 1/4"
B. 129

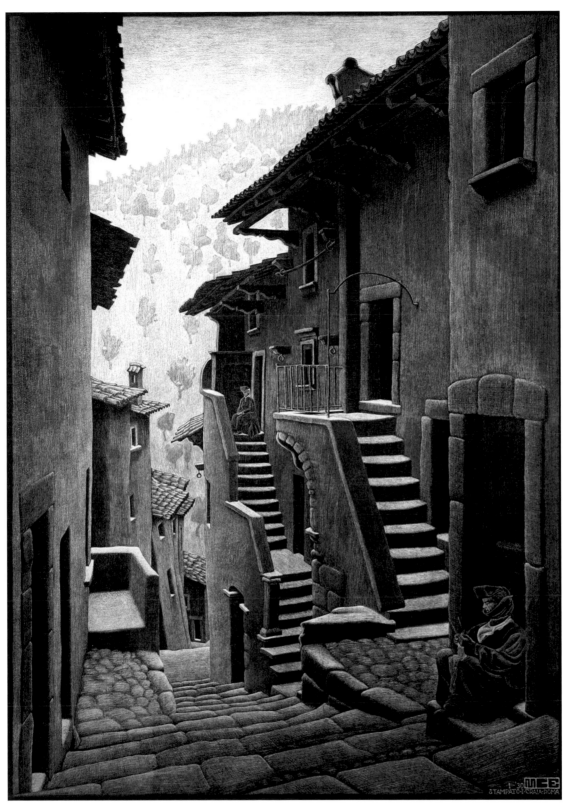

Street in Scanno, Abruzzi, 1930, lithograph, 24 5/8" x 17"
B. 131

Aloe plant in Tropea, 1930, pencil, 9 1/2" x 12 1/4"
T755-x-1971, microfiche 465

Tropea, 1930, pencil, 25 1/8" x 18 5/8"
T118-x-1969, microfiche 1643

Preliminary drawing for Castrovalva, 1930, pencil, 10 3/4" x 5"
T762-x-1971, microfiche 471

Rufalo spiny plant (see Castrovalva), 1930, ink, 12 1/2" x 15 1/4"
T961-x-1971, microfiche 460

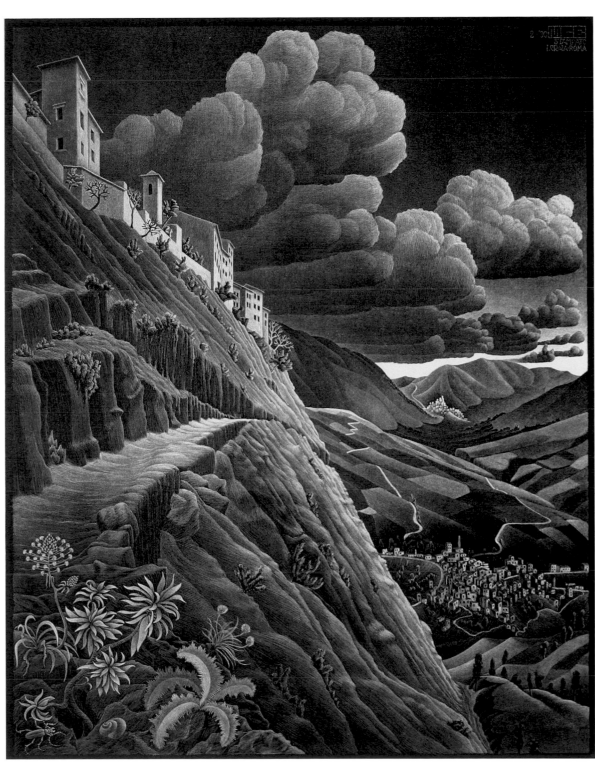

Castrovalva, 1930, lithograph, 20 7/8" x 16 5/8"
B. 132

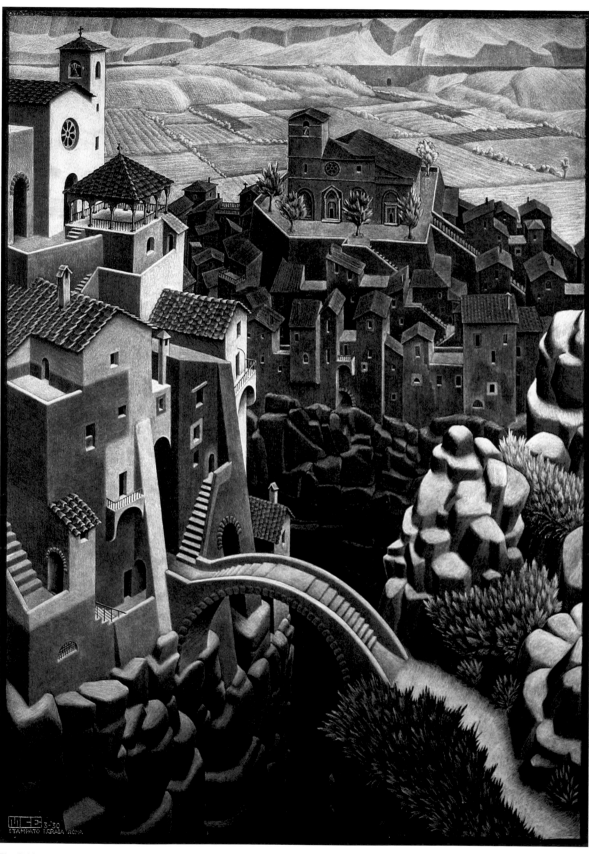

The Bridge, 1930, lithograph, 21 1/8" x 14 7/8"
B. 134

42

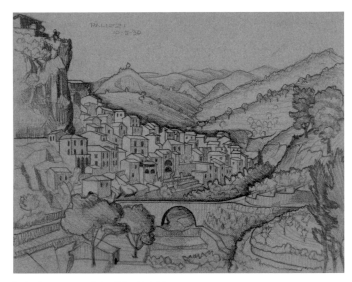

Palizzi, 1930, pencil, 9 1/2" x 12 3/8"
T863-x-1971, microfiche 571

Holy figures, circa 1925, pencil, 8 7/8" x 7 13/16"
T290-x-1969, microfiche 1110

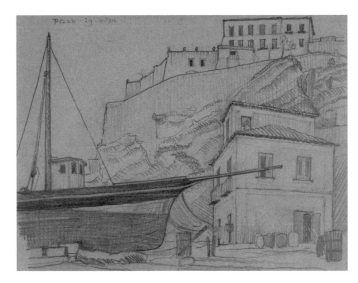

Pizzo, 29-4-'30, pencil, 9 5/16" x 12 3/8"
T857-x-1971, microfiche 565

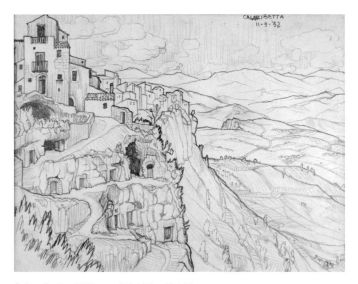

Calascibetta, 1932, pencil, 9 1/4" x 12 1/4"
T945-x-1971, microfiche 646

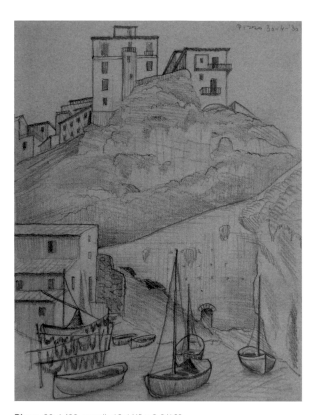

Pizzo, 30-4-'30, pencil, 12 1/4" x 9 9/16"
T860-x-1971, microfiche 568

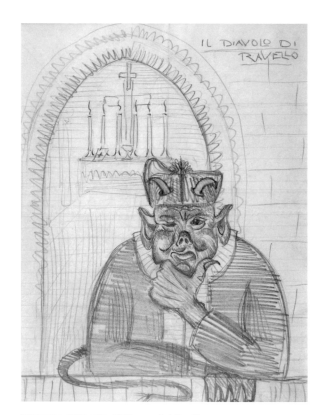

Il Diavolo di Ravello, 1931, pencil, 11" x 8"
T699-x-1971, microfiche 408

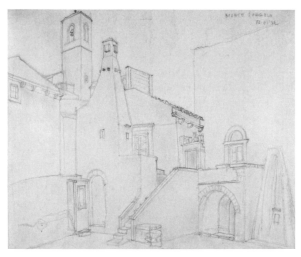

Monte St. Angelo, 1932, pencil, 9 3/4" x 12 3/4"
T733-x-1971, microfiche 442

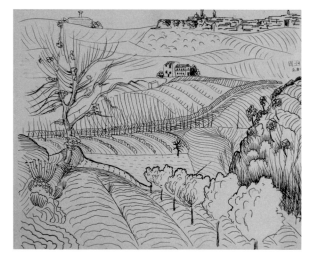

Farm and Hills, circa 1925, ink, 8 1/4" x 10 1/8"
T743-x-1971, microfiche 452

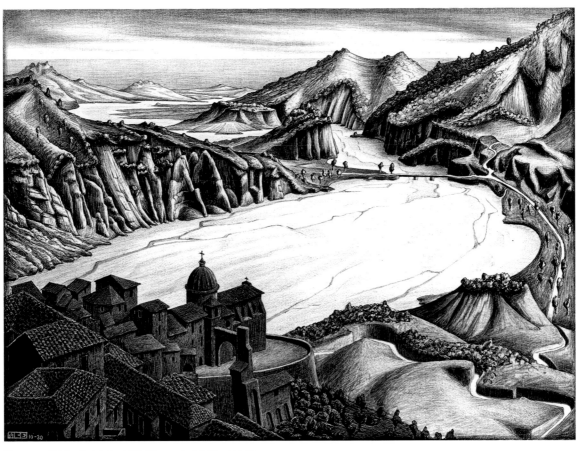

Fiumara of Stilo, Calabria, 1930, lithograph, 8 7/8" x 11 3/4"
B. 138

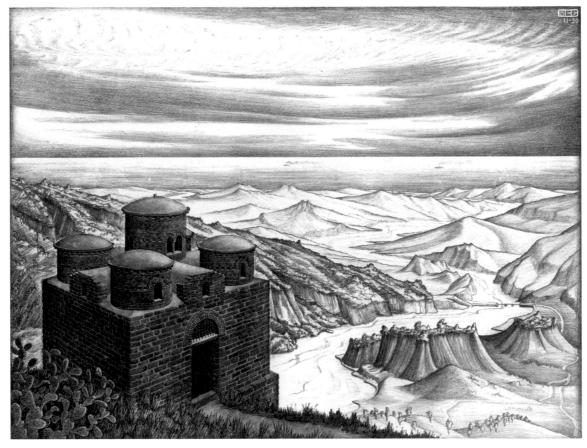

Cattolica di Stilo, Calabria, 1930, lithograph, 8 7/8" x 11 3/4"
B. 139

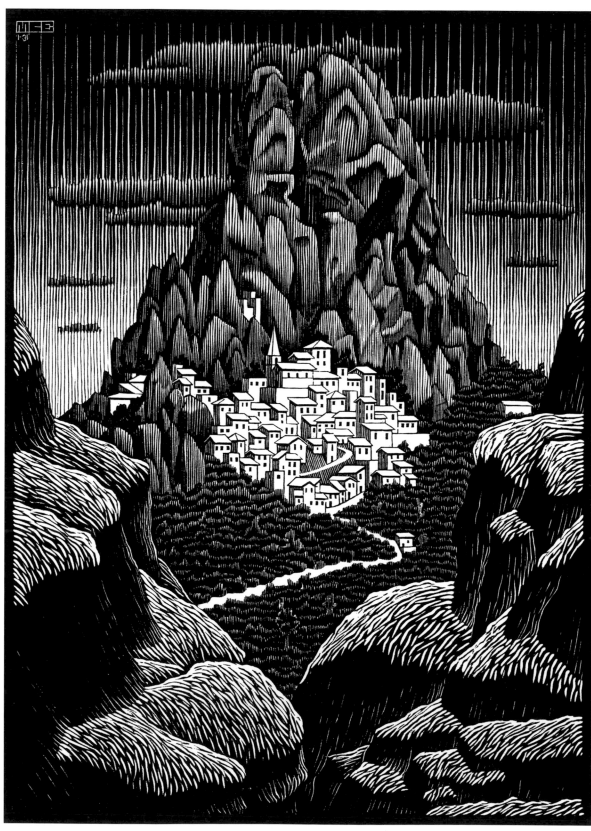

Pentedattilo, Calabria, 1931, woodcut, 12 5/8" x 9 1/8"
B. 141

46

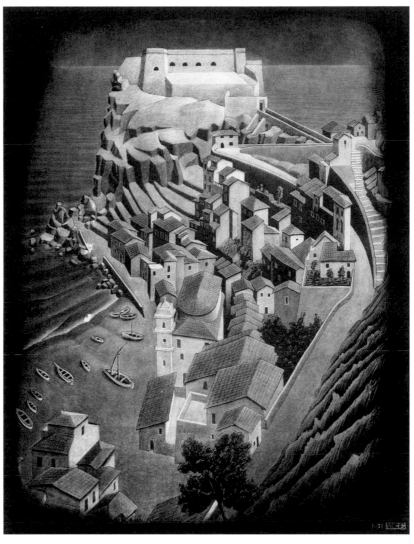

Scilla, Calabria, 1931, lithograph, 11 3/4" x 8 7/8"
B. 142

Vernazza, 1933, pencil, 15 3/8" x 20 1/2"
T70-x-1969, microfiche 1627

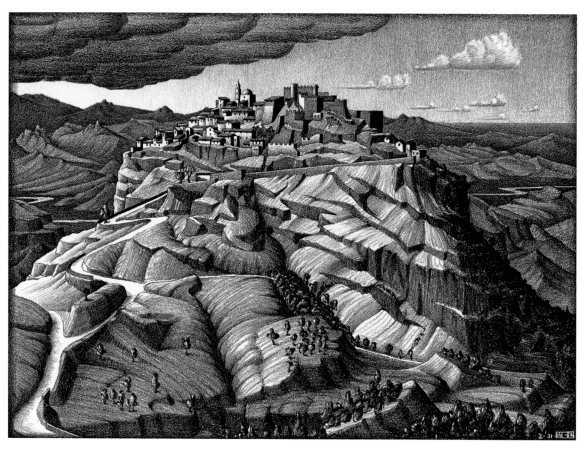

Santa Severina, Calabria, 1931, lithograph, 9 1/8" x 12 1/4"
B. 144

48

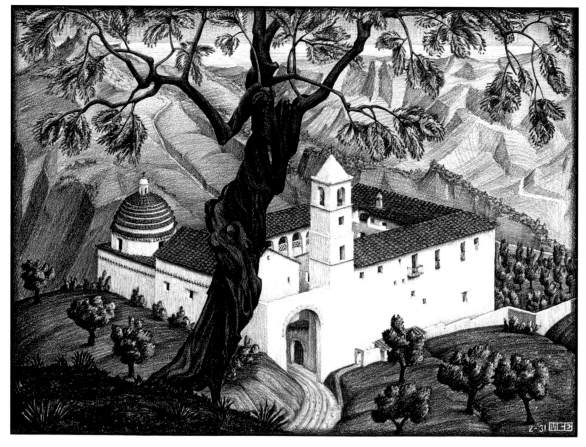

Cloister of Rocca Imperiale, Calabria, 1931, lithograph, 9 1/8" x 12 1/8"
B. 145

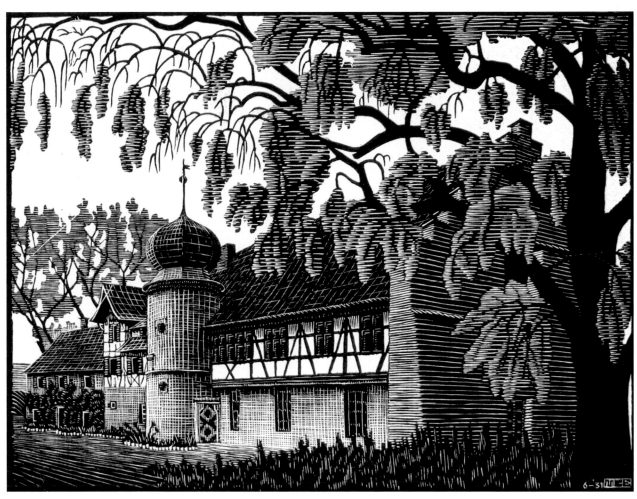

Canteen at Steckborn, 1931, woodcut, 8 1/8" x 10 1/4"
not catalogued by Bool

Canteen at Steckborn is one of two prints that was not known to F.H. Bool when he catalogued Escher's prints, and is the only one for which examples are known to exist. The other, for which there is documentation but no known example, was an anti-Nazi scatological woodcut about a toilet that, at great risk, Escher printed and distributed during World War II. The image picture here was done for Jetta's brother-in-law who ran a rayon factory in Switzerland. The building is now a hotel.

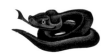

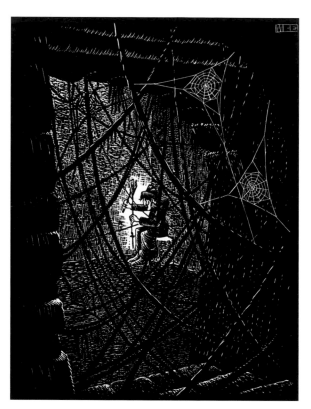

Cobwebs, 1931, woodcut, 7" x 5 3/8"
B. 154

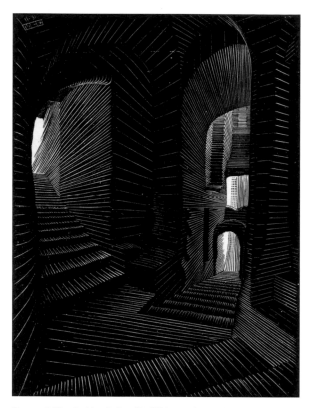

Covered Alley in Atrani, Amalfi, 1931, wood engraving, 7 1/8" x 5 1/8"
B. 150

50

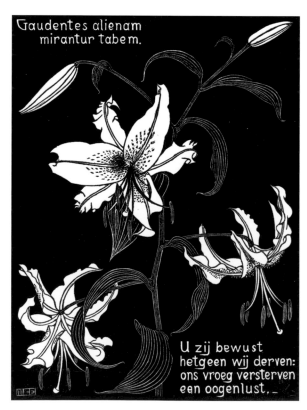

Lilies, 1931, woodcut, 7 1/8" x 5 3/8"
B. 156

Emblemata

At the end of 1930 Escher returned home from southern Italy defeated and depressed. He was unable to sell his work and suffered both physically and financially. He doubted his own skills and questioned whether he should continue working as an artist.

The Dutch art historian G.J. Hoogewerff suggested to Escher that he make an *emblemata*, a collection of illustrated four-line epigrams with Latin mottos. Hoogewerff provided many of the epigrams and subsequently praised Escher's work in an article. The inspiration and support he received from Hoogewerff helped encourage Escher to press onward with his career.

Escher created the illusion of gray tones by varying the width and proximity of the white lines. Notice the shadow of the *Dice* or the light emanating from the *Candle*. Some prints contain motifs of future creations. The *Butterfly* is a mosaic of images. The *Frog* appears to be a precursor for both *Rippled Surface* and *Three Worlds*.

XXIV Emblemata, 1932, book with 27 woodcuts, text by A. E. Drijfhout (pseudonym for G.J. Hoogewerff), 7 1/8" x 5 1/2"
B. 159-186

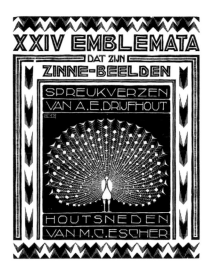

Second title page

First title page

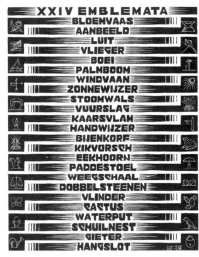

Table of Contents

Vase

Anvil

Lute

Kite

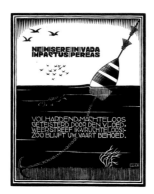

Buoy

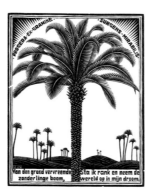

Palm

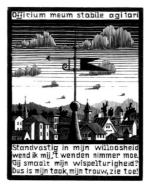

Weather Vane

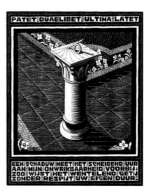

Sundial

Signpost

Frog

Candle Flame

Beehive

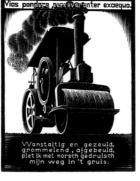

Steamroller

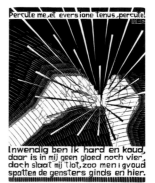

Flint

52

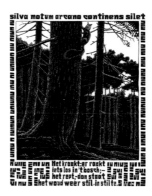

Squirrel

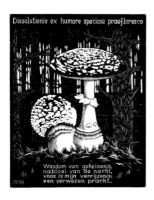

Toadstool

Balance

Cactus

Butterfly

Dice

53

Well

Retreat

Watering Can

Padlock

Scholastica

Escher created the Scholastica Suite to illustrate the book *The Terrible Adventures of Scholastica*. Jan Walch, Escher's acquaintance, wrote the book about the witch of Oudewater. Oudewater is a small town in the Netherlands famous for its Witch's Scales. During the 16th century people accused of witchcraft could try to prove their innocence in the Weighing House. People accused of being witches wanted to be tried in Oudewater because they did not rig their scales. No one was ever found guilty of witchcraft in Oudewater.

None of the woodcuts in the book were given titles by Escher. In addition to the six large woodcuts, there are thirteen smaller ones. Most of them are illustrated letters, but there is a title page and a vignette that concludes the story. The final vignette also is the last print in this catalogue.

De Vreeselijke Avonturen van Scholastica, 1933, book with 19 woodcuts, text by Jan Walch, 3 1/8" x 2 3/8" to 9" x 6 5/8", B. 187-205

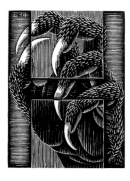 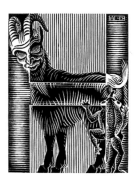 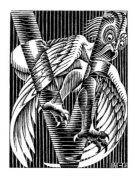 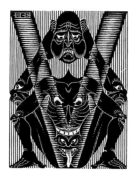

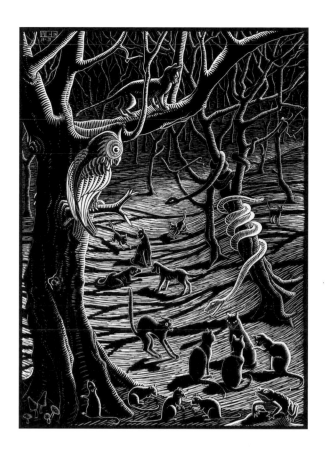

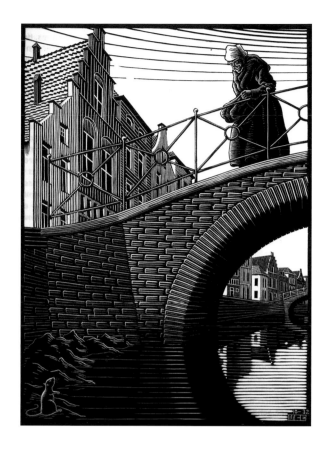

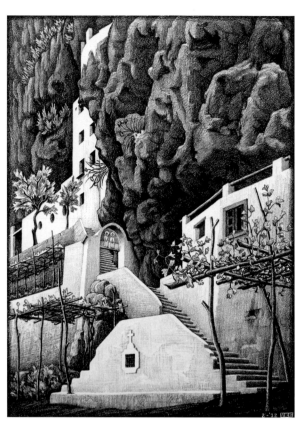

San Cosimo, Ravello, 1932, lithograph, 12 3/8" x 8 3/4"
B. 208

Turello, 1932, lithograph, 12 1/4" x 8 7/8"
B. 209

56

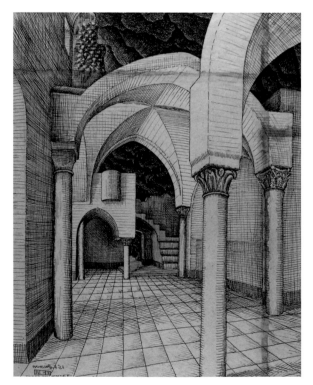

Chiesa dell Ospedale, Ravello, 1923, ink, 18 1/4" x 15"
T76-x-1969, microfiche 1556

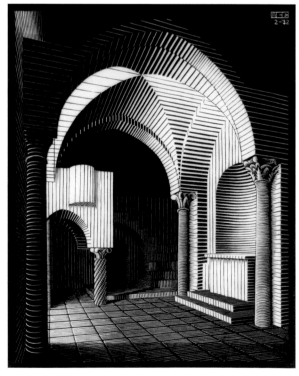

Porta Maria dell'Ospidale, Ravello, 1932, wood engraving, 11" x 8 1/4"
B. 212

Lion of the Fountain in the Piazza at Ravello, 1932, lithograph, 8 3/8" x 9 1/8"
B. 214

San Michele dei Frisoni, Rome, 1932, lithograph, 17 1/8" x 19 3/8"
B. 216

Castel Mola and Mt. Etna, Sicily, 1932, lithograph, 8 7/8" x 12 1/4"
B. 219

58

Cathedral of Cefalu, Sicily, 1932, lithograph, 8 7/8" x 11 1/8"
B. 220

Study of hands, circa 1930, chalk, 9 1/2" x 12 1/2"
T895-x-1971, microfiche 604

Study of hands, circa 1930, pencil, 9 1/2" x 12 1/2"
T895-x-1971, microfiche 604

Cloister of San Monreale, Sicily, 1933, wood engraving, 12 5/8" x 9 1/2"
B. 226

Study for Dutch Peace postage stamp, 1932, pencil, 6" x 13"
T911-x-1971, microfiche 616

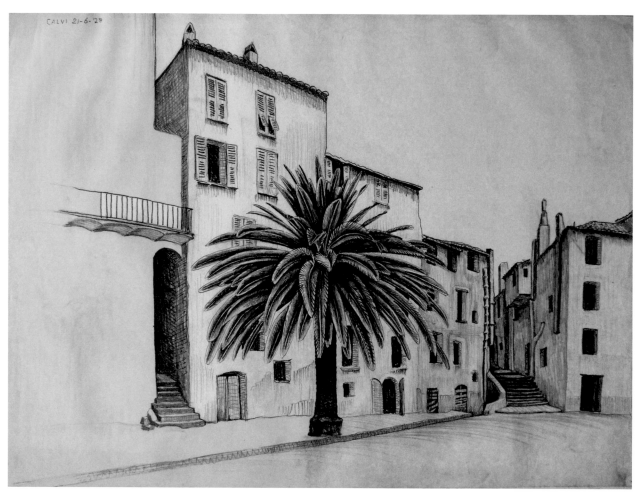

Calvi, 1928, pencil, 26" x 19"
T162-x-1969, microfiche 1617

Palm, 1933, woodblock, 15 5/8" by 15 5/8"
B. 223

Palm, 1933, woodblock, 15 5/8" by 15 5/8"
B. 223

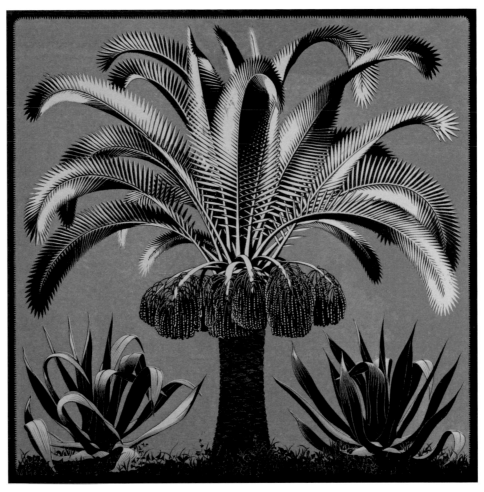

Palm, 1933, wood engraving in three color variants, printed from two blocks, (final state), 15 5/8" x 15 5/8"
B. 223

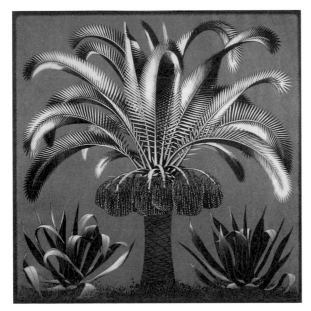

Palm, 1933, wood engraving, printed from two blocks, (unique colored print), 15 5/8" x 15 5/8", B. 223

Palm, 1933, wood engraving, printed from two blocks, (unique colored print), 15 5/8" x 15 5/8", B. 223

Phosphorescent Sea, 1933, lithograph, 12 7/8" x 9 5/8"
B. 231

62

Lava Flow, Sicily, 1933, lithograph, 8 3/8" x 12 3/8"
B. 229

Fireworks, 1933, lithograph, 16 3/4" x 8 7/8"
B. 239

Rome by Night

Escher created the drawings for each of his Rome by Night prints by torchlight at night. Then he experimented with different cutting techniques to recreate the images as woodcuts. Escher, when looking back on the years 1922 to 1935, remarked that the woodcuts and lithographs of that time period were practice exercises in which he learned the characteristics and limitations of his materials.

The first two woodcuts utilize straight lines to convey every shape, including curves. The second two images are comprised of small crosses and hash marks. Other images in this series (not pictured) are composed of grids and horizontal lines.

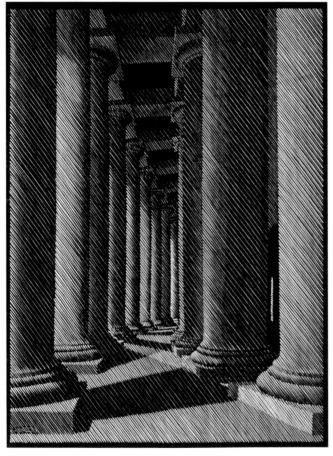

Nocturnal Rome: Colonnade of St. Peter, 1934, woodcut, 12 1/4" x 9" B. 250

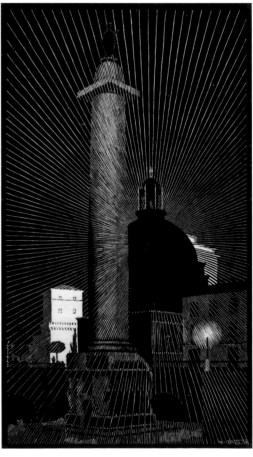

Nocturnal Rome: Trajan's Column, 1934, woodcut, 13 1/8" x 7 1/4", B. 257

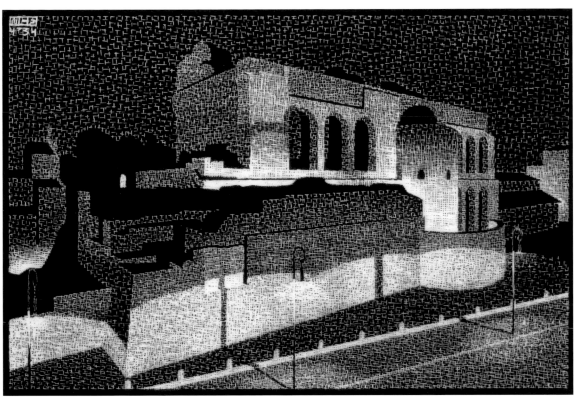

Basilica of Constantine, 1934, woodcut, 8 1/4" x 12 1/4"
B. 258

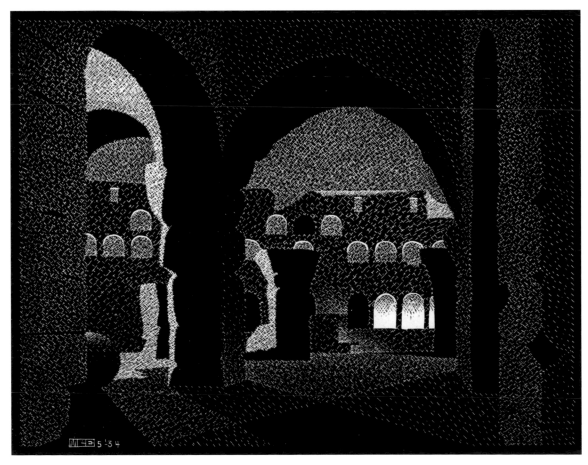

Colosseum, 1934, woodcut, 9" x 11 5/8"
B. 260

68

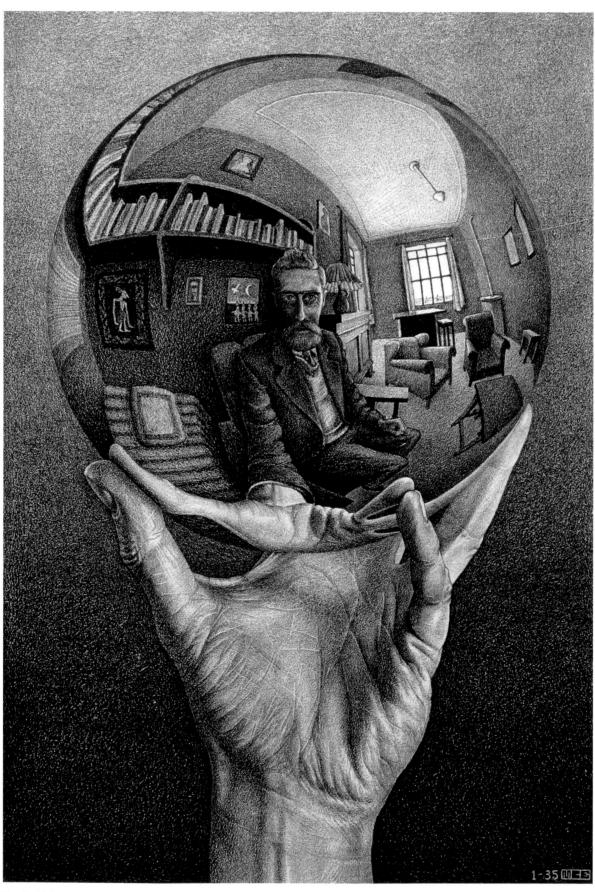

Hand with Reflecting Sphere, 1935, lithograph, 12 1/2" x 8 3/8"
B. 268

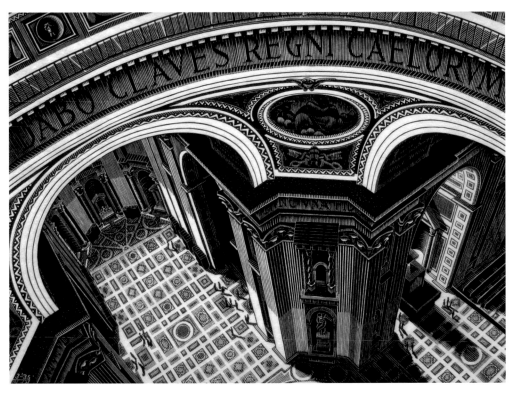

Inside St. Peter's, 1935, wood engraving, 9 3/8" x 12 1/2"
B. 270

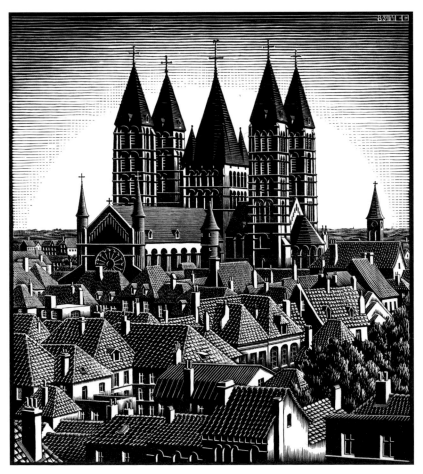

Tournai (Doornik) Cathedral, 1934, woodcut, 16 1/8" x 14 3/8"
B. 262

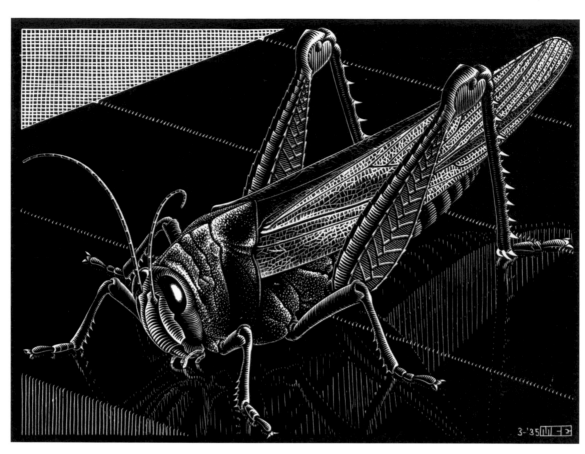

Grasshopper, 1935, wood engraving, 7 1/8" x 9 1/2"
B. 271

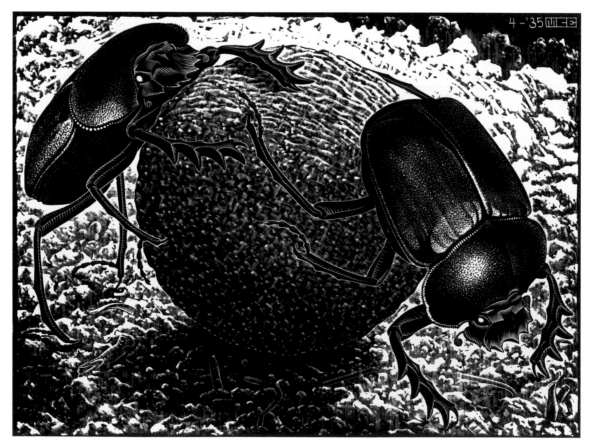

Scarabs, 1935, wood engraving, 7 1/8" x 9 1/2"
B. 273

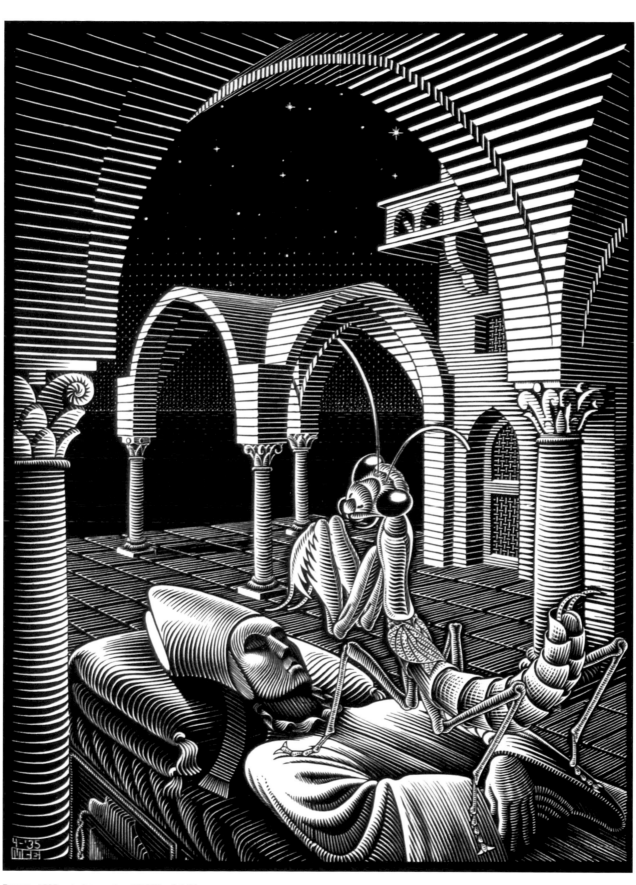

Dream, 1935, wood engraving, 12 5/8" x 9 1/2"
B. 272

Development I, 1937, woodcut, 17 1/4" x 17 1/2"
B. 300

The Heavy Heart, 1937, woodcut, 3 1/4" x 2 1/2"
B. 299

Program for St. Matthew Passion, 1938,
woodcut, 6" x 4 1/8", B. 302

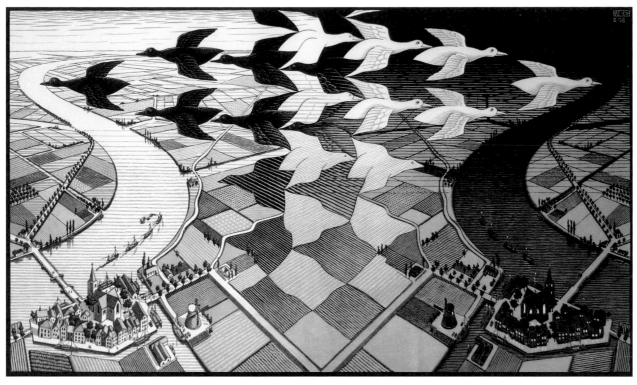

Day and Night, 1938, woodcut printed from two blocks, 15 3/8" x 26 5/8"
B. 303

Alhambra tiling pattern, circa 1936, gouache and pencil, 17" x 13"
T94-x-1972, microfiche 1182

Escher's trip to the Alhambra in 1936 had a profound effect on the rest of his life. It renewed his interest in tiling animals, something he had tried without great success fifteen years earlier.

A second important factor influenced his interest in tessellations about the same time. Escher wrote in *The Graphic Work*, "In Switzerland, Belgium and Holland where I successively established myself, I found the outward appearance of landscape and architecture less striking than those which are particularly to be seen in the southern part of Italy. Thus I felt compelled to withdraw from the more or less direct and true to life illustrating of my surroundings. No doubt this circumstance was in a high degree responsible for bringing my inner visions into being."

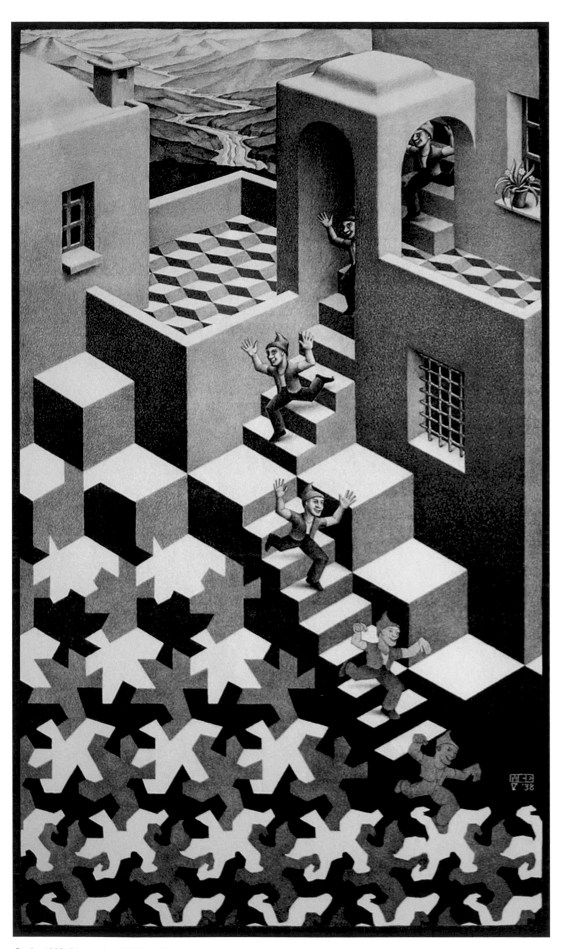

Cycle, 1938, lithograph, 18 3/4" x 11"
B. 305

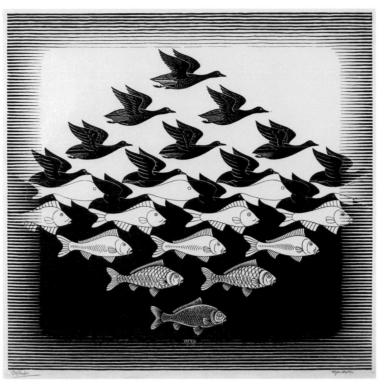

Sky and Water I, 1936, woodcut, 17 1/8" x 17 1/4"
B. 306

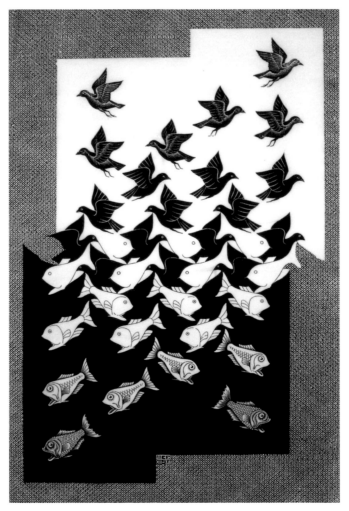

Sky and Water II, 1938, woodcut, 24 1/2" x 16"
B. 308

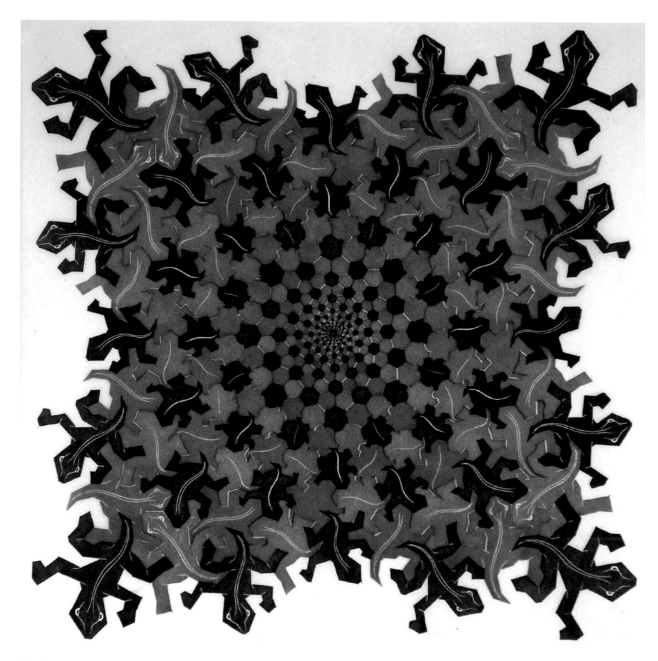

Development II, 1939, woodcut printed from three blocks, 17 7/8" x 17 7/8"
B. 310

Escher was dissatisfied with *Development I* because the lizards were confined as they came into being. *Development II* allowed the lizards to roam free once disconnected from their hexagonal beginnings. Incidentally, this is Escher's first print of many to represent infinity in the center of the image by constructing smaller and smaller shapes that spiral inward...forever.

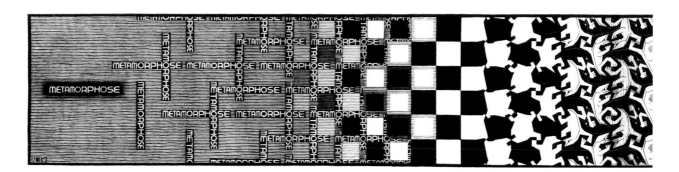

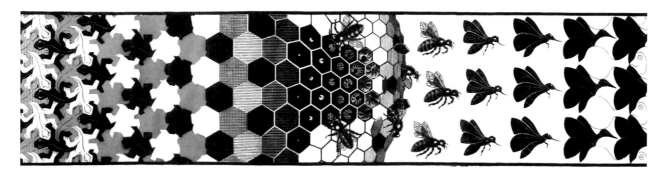

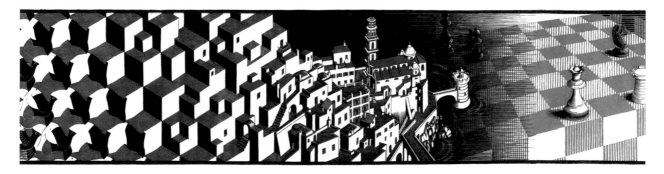

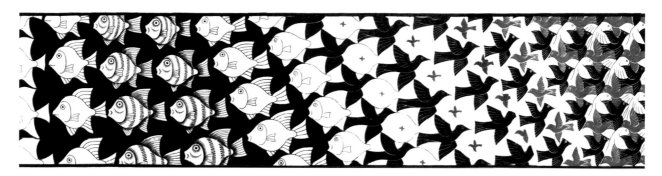

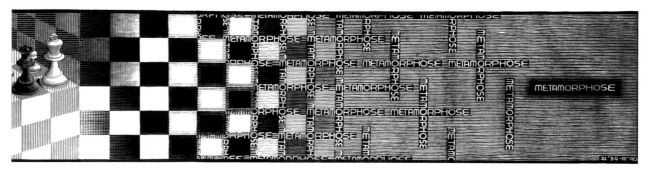

Metamorphosis II, 1940, woodcut printed from twenty blocks, 7 1/2" x 153 3/8"
B. 320

Watercolors

Escher wrote, "A contour line between two interlocking figures has a double function, and the act of tracing such a line therefore presents a special difficulty. On either side of it, a figure takes place simultaneously. But, as the human mind cannot be busy with two things at the same moment, there must be a quick and continuous jumping from one side to the other. The desire to overcome this fascinating difficulty is perhaps the very reason for my continuing activity in this field."

Escher created a series of 137 numbered watercolors, with some pieces having lettered variants, as a log of tessellations. Often an idea would start as a simple sketch on graph paper like the one pictured on the right. The tessellations that met Escher's approval were redrawn and painted. These one-of-a-kind watercolors served as inspiration for future woodcuts and lithographs. Escher never offered them for sale.

Reversing Cubes, pencil and crayon, 6 1/2" x 11", T149-x-1972, microfiche 1219

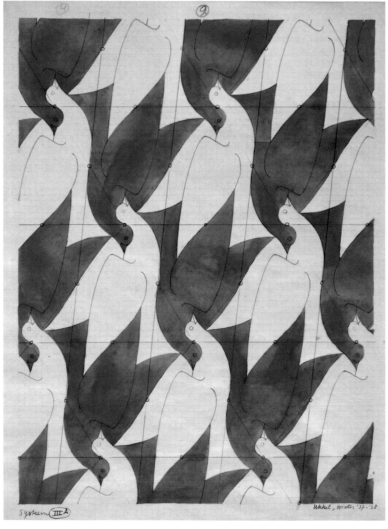

Symmetry Drawing 9,1937-38, watercolor, pen and pencil, 10 1/2" x 14"
T248-x-1972, microfiche 675

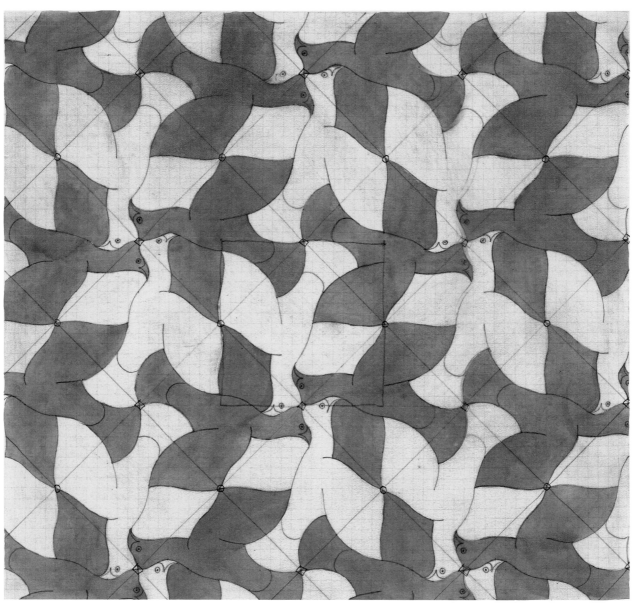

Symmetry Drawing 23, 1938, watercolor, pen and pencil, 9" x 9 5/8"
T259-x-1972, microfiche 689

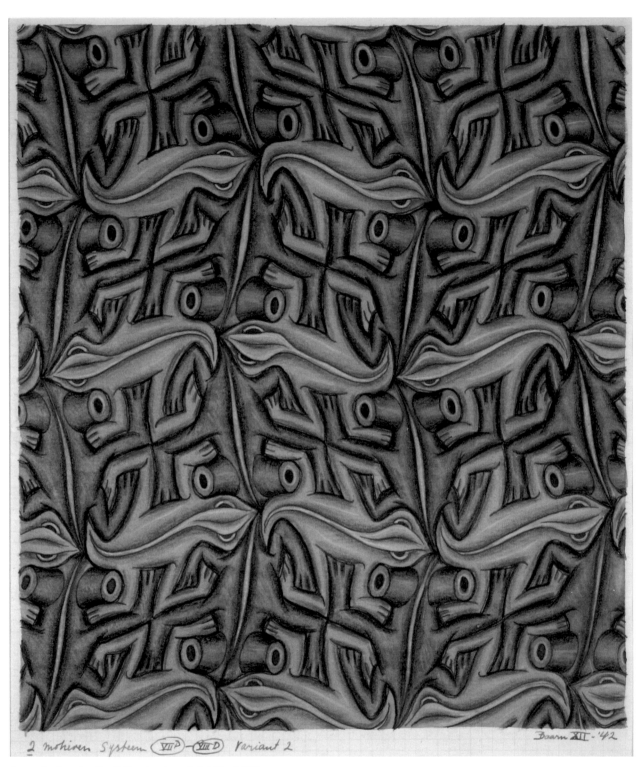

2 motieven Systeem (VII^P)-(VII D) Variant 2 Baarn XII - '42

Symmetry Drawing 60, 1942, colored pencil, 9 1/2" x 8 7/8"
T337-x-1972, microfiche 751

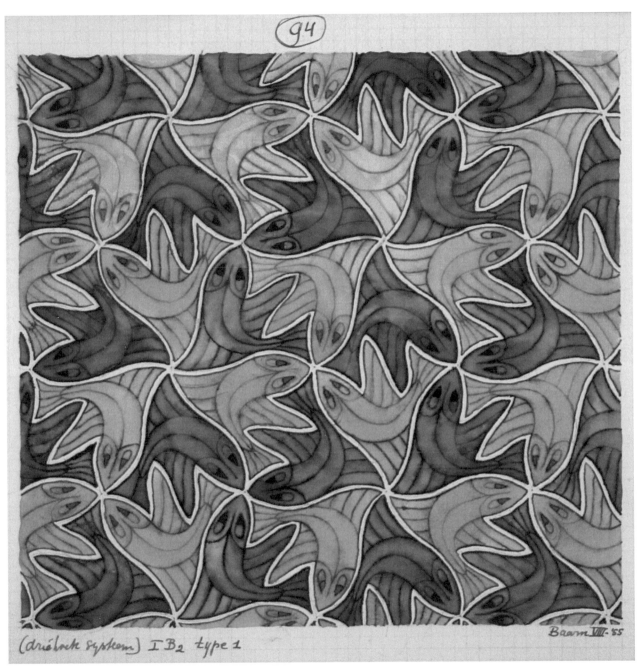

Symmetry Drawing 94, 1955, watercolor, 9 1/2" x 8 7/8"
T324-x-1972, microfiche 732

Symmetry Drawing 108, 1961, watercolor and ink, 9 1/2" x 8 7/8"
T337-x-1972, microfiche 773

Symmetry Drawing 134, 1967, ink, 11 7/8" x 8 7/8"
T361-x-1972, microfiche 796

Symmetry Drawing 136, 1968, ink, 12" x 9 3/8"
T362-x-1972, microfiche 797

Tile designed for column by New Lyceum, porcelain tile, 9 1/2" x 9 1/8"

study for regular division of the plane, pencil,
8" x 15 5/8", T145-x-1972, microfiche 1207

Study for banknote, ink on grid paper, 9 3/4" x 14 1/2"
T299-x-1971, microfiche 1496

Study for regular division of the plane, pencil
and watercolor, 8 1/2" x 10 1/8"
T109-x-1972, microfiche 1245

Escher and Verbum

Escher's oldest son, George, writes, "I do not remember any prints other than Verbum hanging on the walls of father's studio in Baarn. I took this picture in 1958 one month or so before leaving for Canada. Father was pleased with the print, since he achieved his goal of depicting together the life of worlds of land, water and sky, night and day in a balanced way. The Verbum logo in the center of the composition occured as a lucky afterthought. It served as a means of filling the central grey spot in a way which happened to add a philosophical twist to the print."

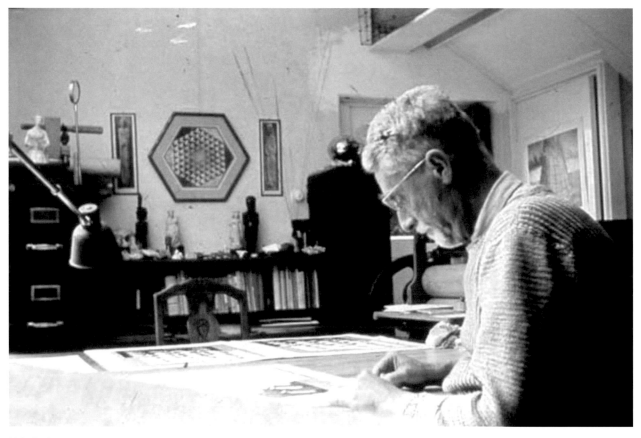

M.C. Escher

Verbum means word in Latin, the Greek translation being logos. The Wikipedia article on logos includes these points: "Heraclitus (ca. 535 – ca. 475 BC) established the term in Western philosophy as meaning both the source and fundamental order of the cosmos. The Gospel of John identifies Jesus as the incarnation of the Logos, through which all things are made. Pope Benedict XVI referred to the Christian religion as the religion of the Logos, since it is faith in the 'Creator Spiritus,' in the Creator Spirit, from which proceeds everything that exists."

Escher's *Verbum* expresses visually the creation by the Word of God as described in the first chapter of Genesis. Escher wrote, "The central word 'Verbum' recalls the biblical story of creation. Out of a misty gray there loom triangular primeval figures which, by the time they reach the edges of the hexagon, have developed into birds, fishes and frogs, each in its own element: air, water and earth. Each kind is pictured by day and by night, and the creatures merge into each other as they move forward along the outline of the hexagon, in a clockwise direction."

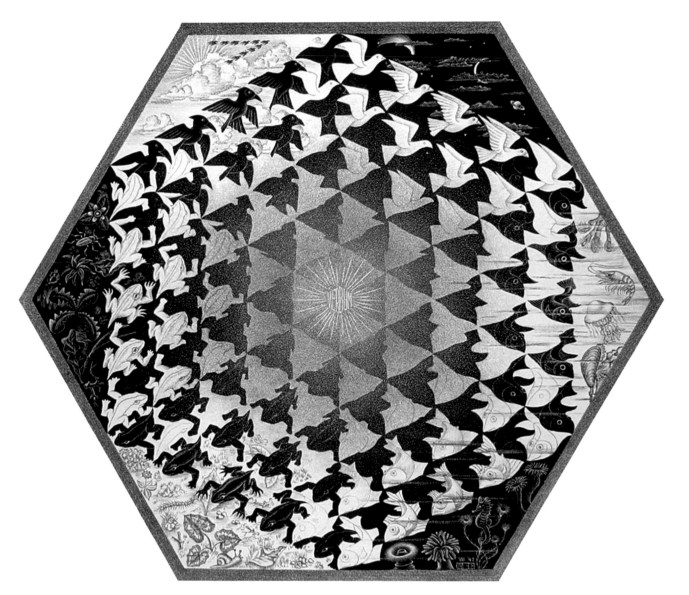

Verbum, 1942, lithograph, 13 1/8" x 15 1/4"
B. 326

Verbum contains each of three key elements in Escher's work – tessellation, metamorphosis, and play of two to three dimensions. In addition, it is unique among his mature works in incorporating Biblical references and in melding image and text.

Verbum was Escher's only major print in 1942. There are six symmetry preparatory watercolors for the print, more than for any other print.

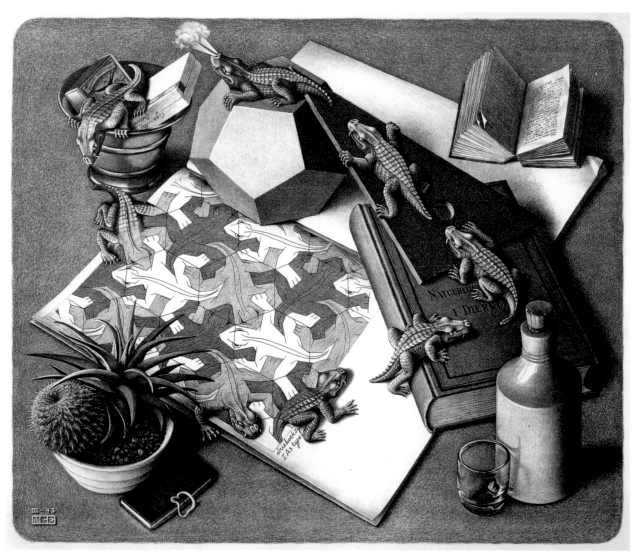

Reptiles, 1943, lithograph, 13 1/8" x 15 1/8"
B. 327

Lizards Tiling Motif, 1941, woodcut, 4 7/8" x 6 1/8"
B. 324

Escher explained "Reptiles" simply as a lizard bored with two dimensions. The lizard escapes the paper, climbs across a zoology book, across a dodecahedron, and down and around to re-enter the paper. Others have attributed deeper meaning such as reincarnation to this circular path. Escher responded that "one can be symbolizing without knowing it."

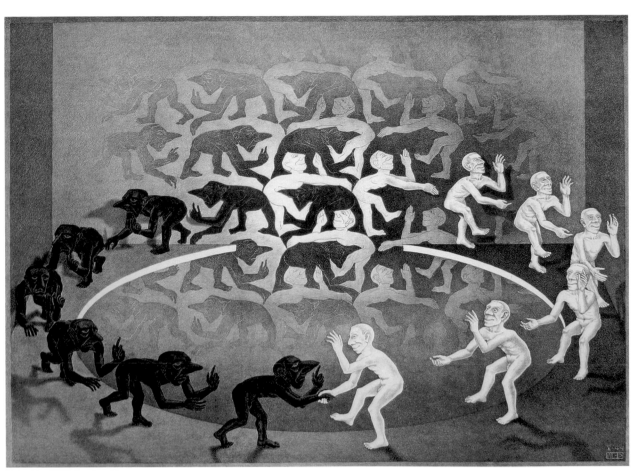

Encounter, 1944, lithograph, 13 1/2" x 18 1/4"
B. 331

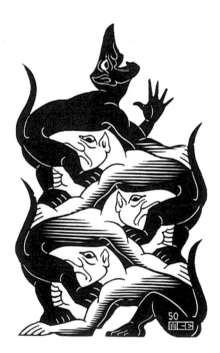

Devils vignette, 1950, wood engraving, 3 7/8" x 2 3/8"
B. 370

The tessellating devils were used to tessellate with themselves in a woodcut and a watercolor. They might also be the inspiration for the men in the lithograph *Encounter*. The 'encounter' is the meeting of a happy optimist and a cautious pessimist according to Escher.

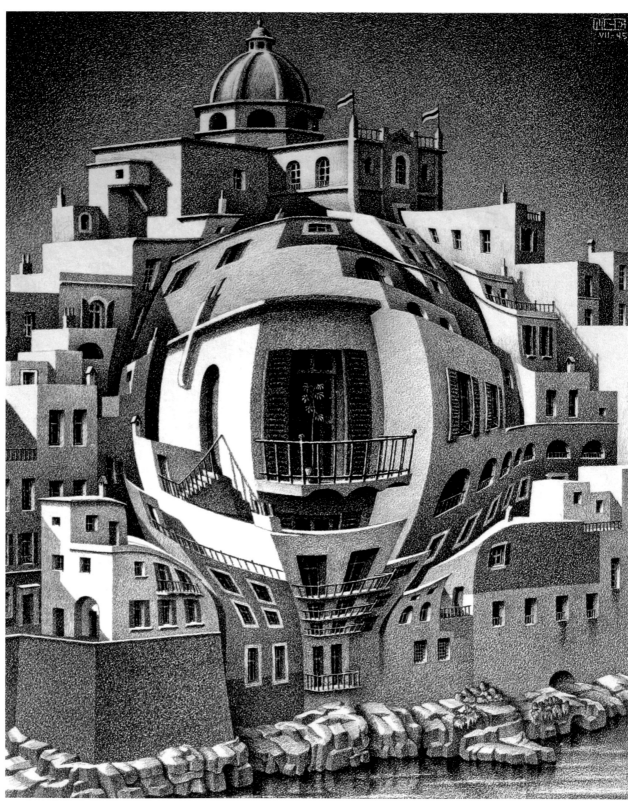

Balcony, 1945, lithograph, 11 3/4" x 9 1/4"
B. 334

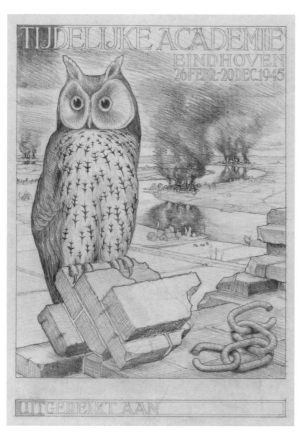

Owl (Diploma), 1945, pencil drawing, 13 1/2" x 9 1/2"
T95-x-1969, microfiche 1251

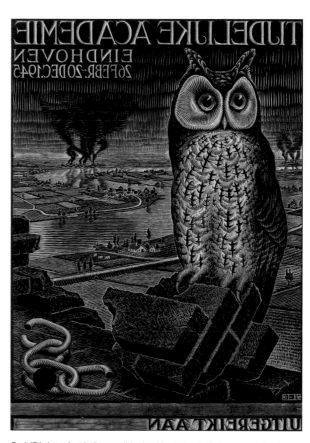

Owl (Diploma), 1945, woodblock with white chalk in grooves to show
definition, 13 1/2" x 9 1/2", B. 337

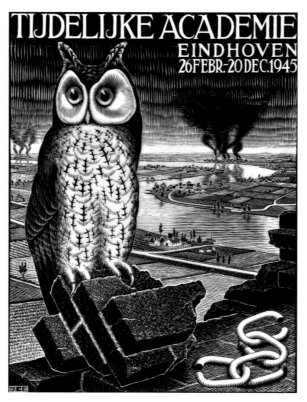

Owl (Diploma), 1945, wood engraving, 13 1/2" x 9 1/2"
B. 337

Two and Three Dimensions

Doric Columns and *Three Spheres I* represent the interplay between something we "see" as three dimensional when, in fact, it is two dimensional.

In *Doric Columns*, both columns are entirely two dimensional. They are flat strips of paper with "column" features drawn onto them. To emphasize this, each strip is folded so that it runs behind the other. The top right corner shows the top of the left column behind the base of the right column. The flat strip then turns ninety degrees to run along the wall. Escher demonstrates that it is only when we see the two dimensional strip at the correct angle (the bottom left for the left strip) does it actually appear three dimensional.

Three Spheres I teaches the same lesson. The top "sphere" is merely a two-dimensional round piece of paper shown at the correct angle. Immediately below it is that same paper folded in half. The bottom image is the same paper lying flat on a table top.

In *Magic Mirror*, the two-dimensional figures arise out of the paper to become three dimensional. The mirror is a two-dimensional reflection of a three-dimensional object. In this case the reflected creatures magically continue into a world behind the mirror only to circle back onto the flat paper.

94

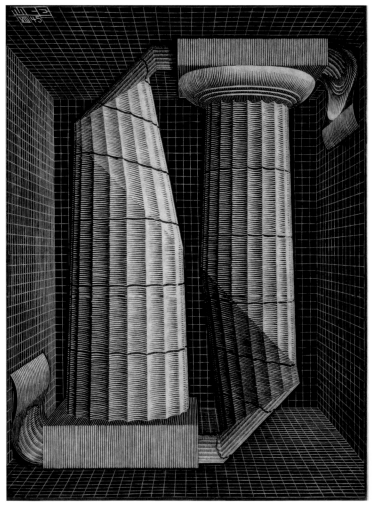

Doric Columns, 1945, wood engraving printed from three blocks, 12 5/8" x 9 1/2"
B. 335

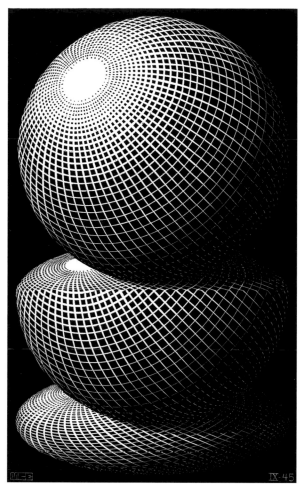

Three Spheres I, 1945, wood engraving, 11" x 6 5/8"
B. 336

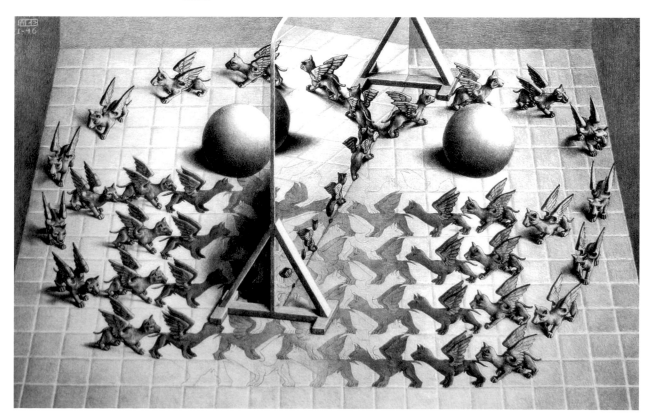

Magic Mirror, 1946, lithograph, 11" x 17 1/2"
B. 338

Bookplates

Bookplates, or *ex libri*, are a way for someone to show ownership of a book. They are stamped or pasted inside the front cover of a book. Throughout his career, Escher occasionally made bookplates for collectors. The first bookplate illustrated here was for his half-brother, Berend George Escher.

Ex libris B.G Escher, 1922, woodcut, 2" x 2"
B. 91

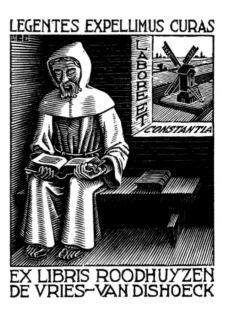

Ex libris D.H. Roodhuyzen, 1942, wood engraving,
3 1/8" x 2 3/8", B. 325

96

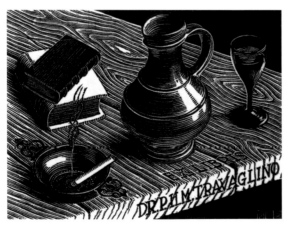

Ex libris Travaglino (Still Life on Table), 1940, wood engraving,
2 3/8" x 3 1/8", B. 321

Ex libris G.H. 's-Gravesande (Open Book), 1940,
wood engraving, 2 3/8" x 2 3/8", B. 322

Ex libris van Dishoeck (Fire), 1943, wood engraving, 3 1/8" x 2 3/8", B. 329

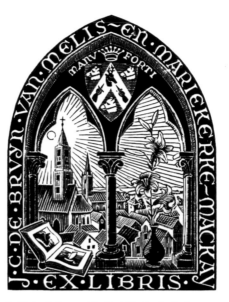

Ex libris de Bruyn (Vaulted Window), 1946, wood engraving, 3 1/8" x 2 3/8", B. 341

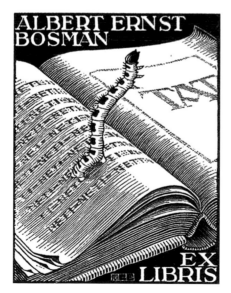

Ex libris Bosman (Bookworm), 1946, wood engraving, 3 1/8" x 2 3/8", B. 347

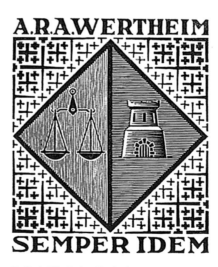

Ex libris Wertheim (Scales), 1954, woodcut, 2 7/8" x 2 1/4", B. 394

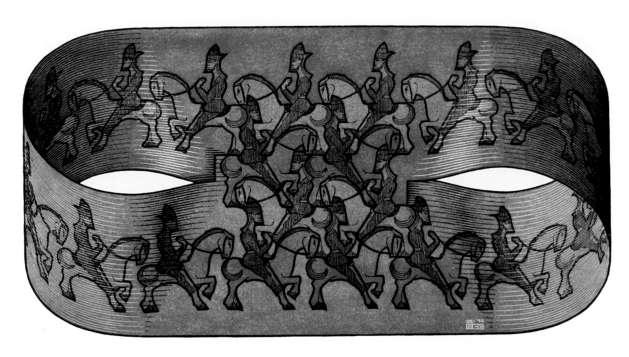

Horseman, 1946, woodcut printed from three blocks, 9 3/8" x 17 5/8"
B. 342

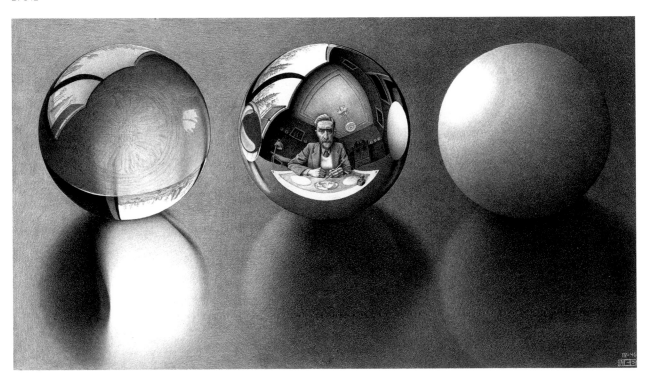

Three Spheres II, 1946, lithograph, 10 5/8" x 18 1/4"
B. 339

Eye (facing page) is a study of reflection as much as Escher's other prints on spherical reflection (*such as Three Spheres II*). Escher created this mezzotint using his own eye. He stated, "It was necessary and logical to portray somebody in the pupil, an observer, reflected in the convex mirror of the eye. I chose the features of Good Man Bones, with whom we are all confronted, whether we like it or not."

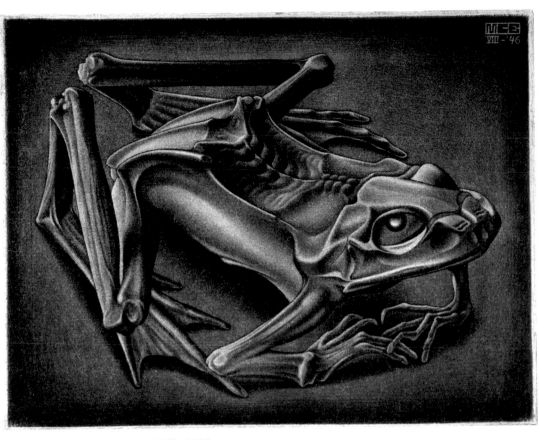

Mummified Frog, 1946, mezzotint, 5 3/8" x 6 3/4"
B. 343

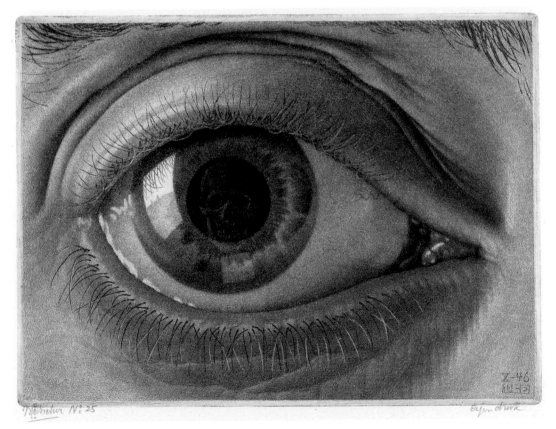

Eye, 1946, mezzotint, 5 1/2" x 7 3/4"
B. 344

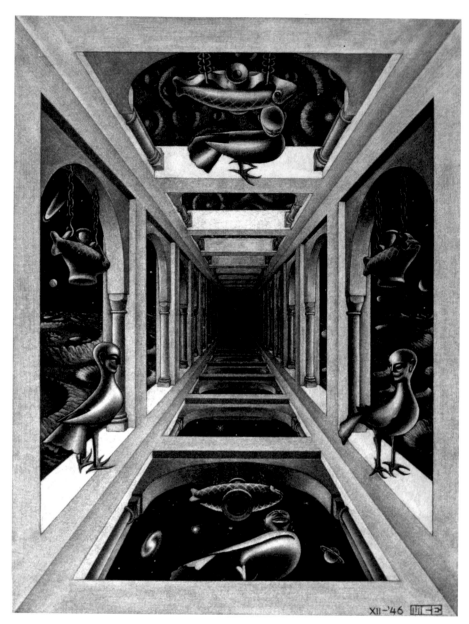

Gallery (Another World), 1946, mezzotint, 8 3/8" x 6 1/4"
B. 346

Another World drawing, circa 1946, pencil, 6 1/2" x 5 1/2"

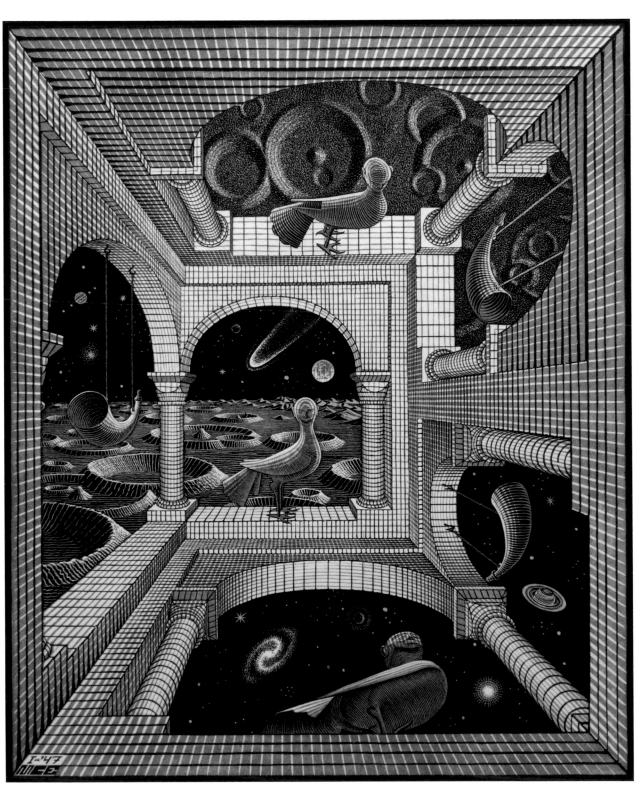

Other World, 1947, woodcut and wood engraving printed from three blocks, 12 1/2" x 10 1/4"
B. 348

Crystal, 1947, mezzotint, 5 1/4" x 6 3/4"
B. 353

Synthesis, 1947, lithograph, 12 1/4" by 12 1/4"
B. 351

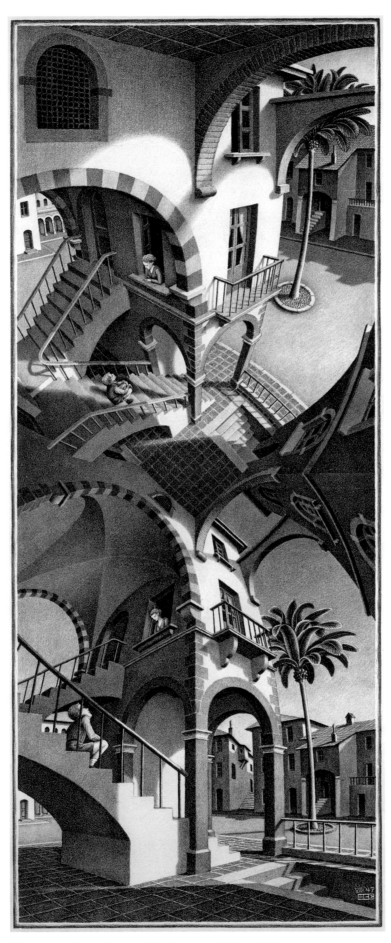

High and Low (Up and Down), 1947, lithograph, 19 3/4" x 8 1/8"
B. 352

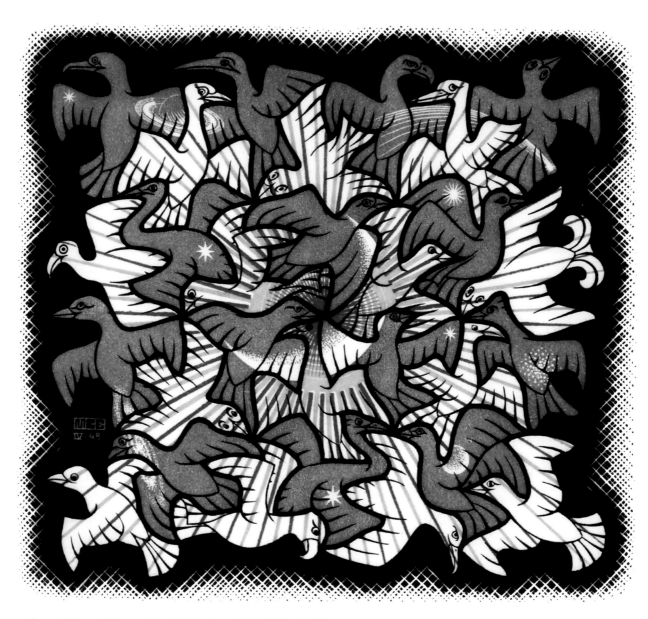

Sun and Moon, 1948, woodcut printed from four blocks, 9 7/8" x 10 5/8"
B. 357

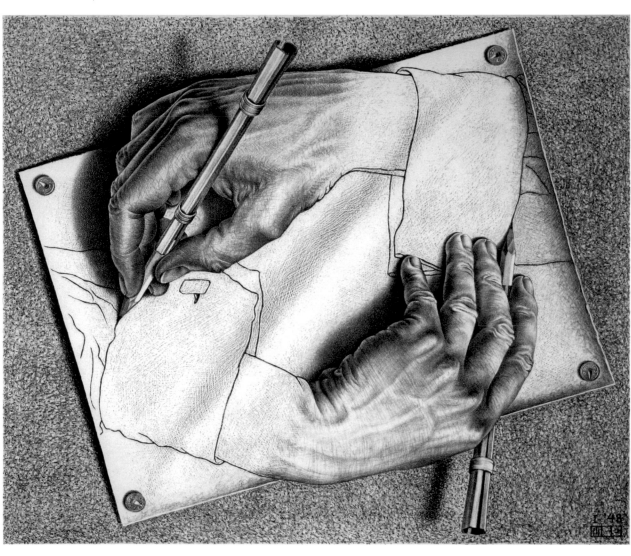

Drawing Hands, 1948, lithograph, 11 1/8" x 13 1/8"
B. 355

Study for Drawing Hands, circa 1948, pencil, 9 3/4" by 10 3/4"
T900-x-1971, microfiche 605

Study for Drawing Hands, circa 1948, pencil, 7 1/2" by 10 3/4"
T902-x-1971, microfiche 607

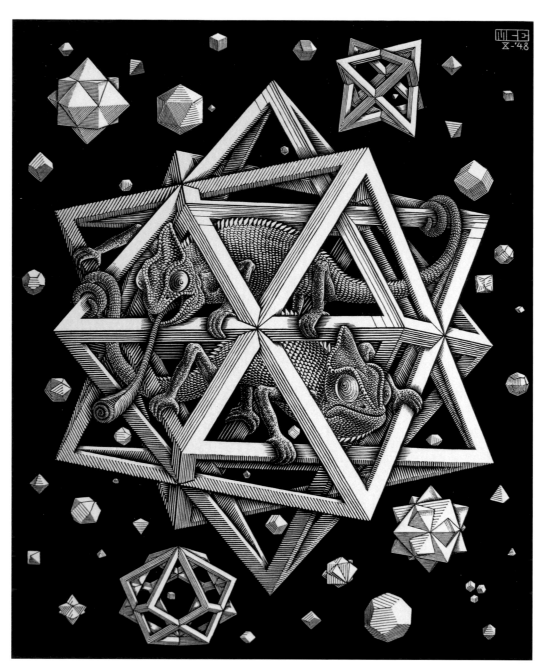

Stars, 1948, wood engraving, 12 5/8" x 10 1/4"
B. 359

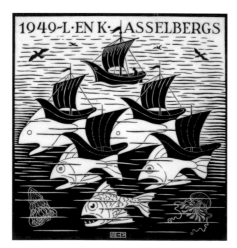

Asselberg's New Years Card (Fishes and Boats),
1948, woodcut, 6" x 5 1/2", B. 360

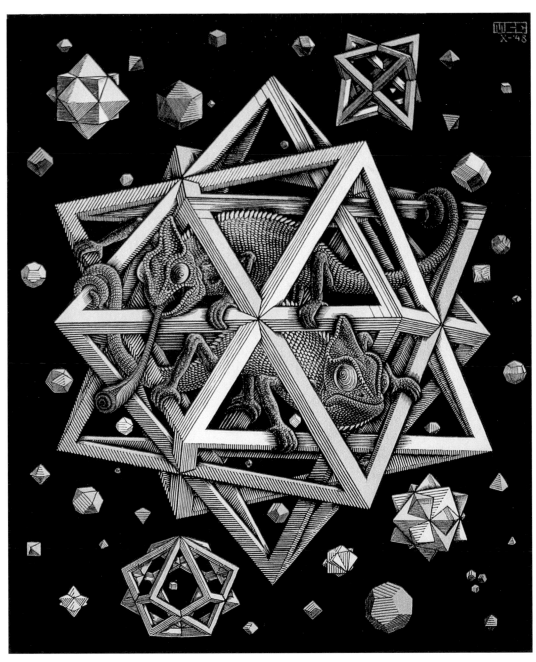

Stars, 1948, wood engraving printed from four blocks with overlapping colors, 12 5/8" x 10 1/4" B. 359 Colors are attenuated.

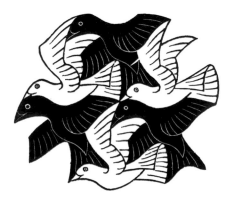

Six Birds, 1949, wood engraving, 2 1/8" x 2 5/8"
B. 361

Horses and Birds (Birds and Ponies), 1949, wood engraving, 3 3/8" x 2 7/8", B. 363

Fishes and Frogs, 1949, wood engraving, 3 1/4" x 2 3/4" B. 364

108

The Well, 1947, woodcut, 4 5/8" x 4" B. 345

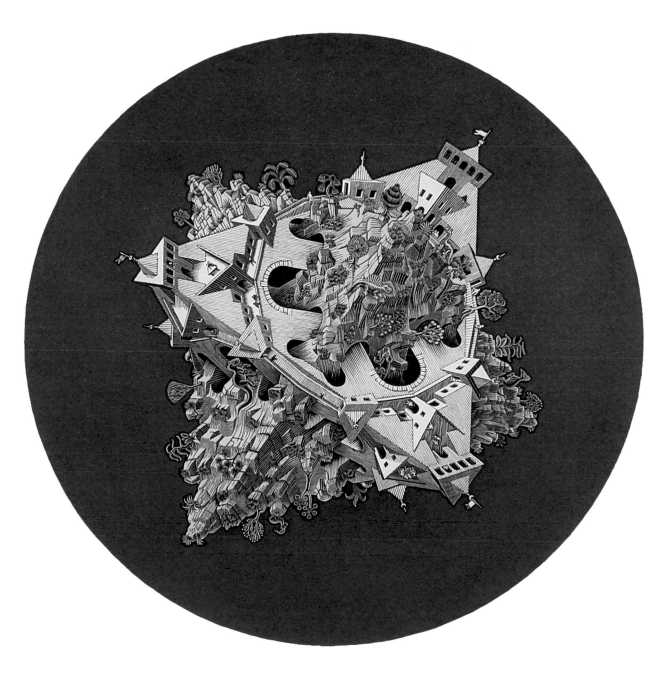

Double Planetoid, 1949, wood engraving and linocut printed from four blocks, 14 3/4" diameter
B. 365

How slowly one moves in a boat that is not floating with the current! How much easier it is to continue the work of illustrious predecessors whose worth is accepted by everyone. A personal experiment, an edifice where one has to dig the foundations and build the walls oneself stands a good chance of turning into a ramshackle shed, and yet one might choose to live there rather than in a palace built by someone else. – M.C. Escher

Escher did not build his own shed, he built his own world...a double planet in this case. Escher stated that the two bodies fit together as one, but the inhabitants have no knowledge of each other.

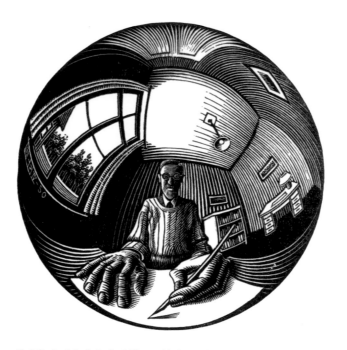

Self Portrait in Spherical Mirror, 1950, woodcut, 3 1/4" diameter
B. 368

Sketches for Damask linen, two-sided, pencil, 13" x 16 11/16"
T296a&b-x-1969, microfiche 1337

Sketches for Damask linen, two-sided, pencil, 13" x 16 11/16"
T296a&b-x-1969, microfiche 1337

Spider web design for a plate, watercolor and pencil, 9 1/8" diameter
T261B-x-1969, microfiche 1259

MOTTO „HUTSPOT"

Motto "Hutspot", ink, watercolor, crayon and Photostat, 13 3/8" x 12"
T294b-x-1969, microfiche 1124

114

Order and Chaos (Contrast), 1950, lithograph, 11" x 11"
B. 366

Assselberg's New Years card (Unicorns),
1950, wood engraving, 4 1/2" x 3 1/8", B. 371

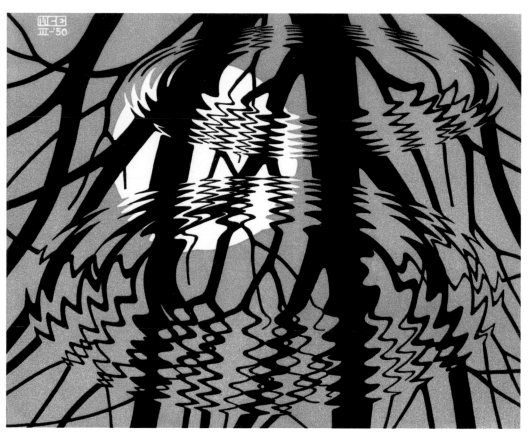

Rippled Surface, 1950, woodcut and linocut from two blocks, 10 1/4" x 12 5/8"
B. 367

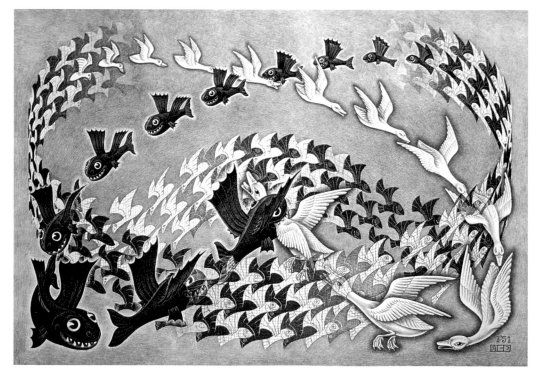

Predestination, 1951, lithograph, 11 5/8" x 16 5/8"
B. 372

The fish and birds in *Predestination* arise from exactly the same shape. This tessellation also is used in *Regular Division of the Plane*.

Two Intersecting Planes, 1952, woodcut printed from three blocks, 8 7/8" x 12 1/4"
B. 377

Four Fish and One Bird, 1951, linocut, 5 3/8" x 6 3/8"
B. 376

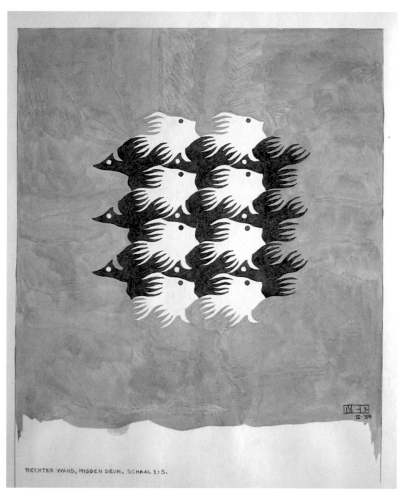

RECHTER WAND, MIDDEN DEUR, SCHAAL 1:5.

Watercolor for fish and birds intarsia, 1954, 12 1/2" x 11 3/4"
T2-x-1987

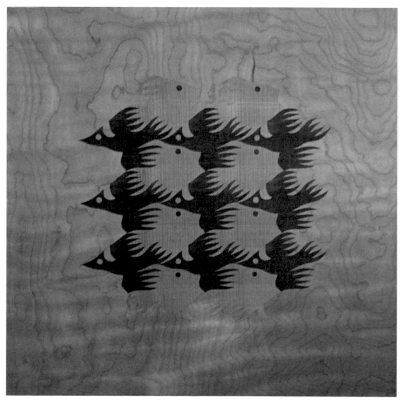

Fish and Birds, wood intarsia, 36" x 36"

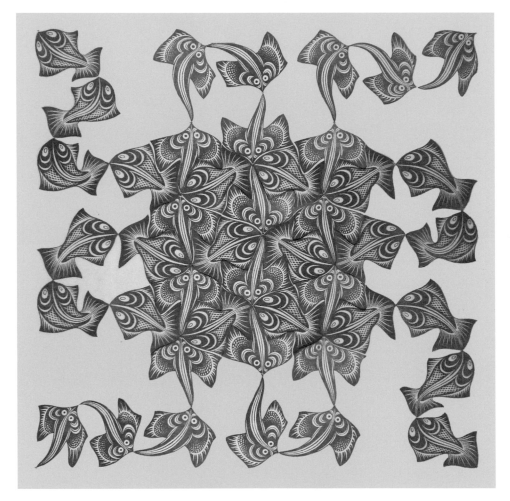

Fish and Skates, circa 1943, woodblocks printed on silk, 13 1/4" x 13 1/4"

Woodblocks for Fish and Skates

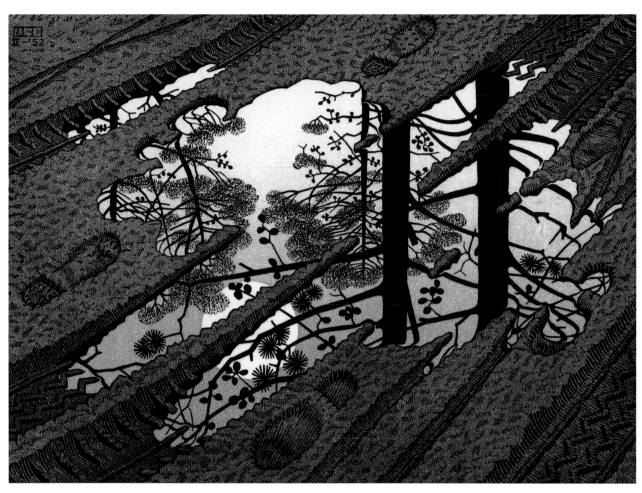

Puddle, 1952, woodcut printed from three blocks, 9 1/2" x 12 1/2"
B. 378

Three dimensional map of Europe, 1952, pencil, 7 1/3" x 8 7/8"
T175-x-1971

4 Graphic Artists, 1952, woodcut, 4" x 3"
B. 381

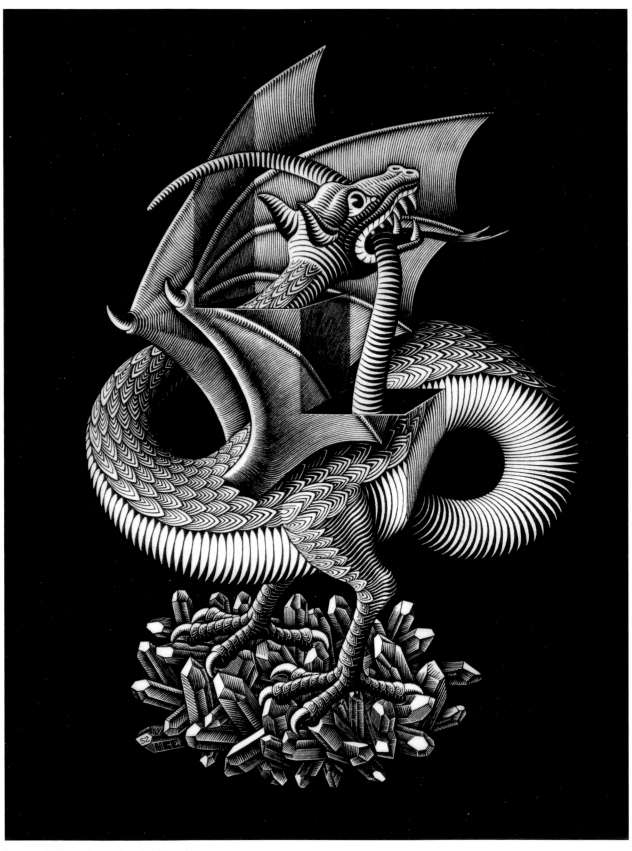

Dragon, 1952, wood engraving, 12 5/8" x 9 1/2"
B. 379

Greeting Cards

Escher was commissioned to design greeting cards as well as *ex libri*. The Strens and the Asselbergs families commissioned Escher on more than one occasion.

Escher created *The Four Elements* (Earth, Air, Fire, Water) for four sequential New Year's cards. There is a variant of the Earth woodcut with the ants in orange and blue.

The Four Elements with preliminary pencil drawing, 1952, woodcuts with letterpress typography, 6 1/8" x 5 3/8"

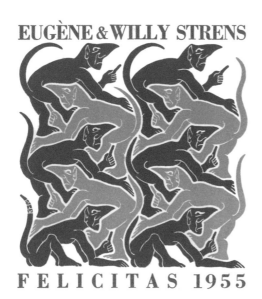

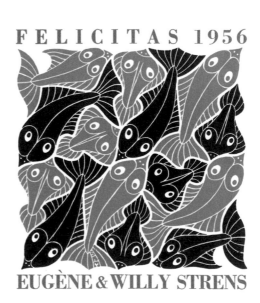

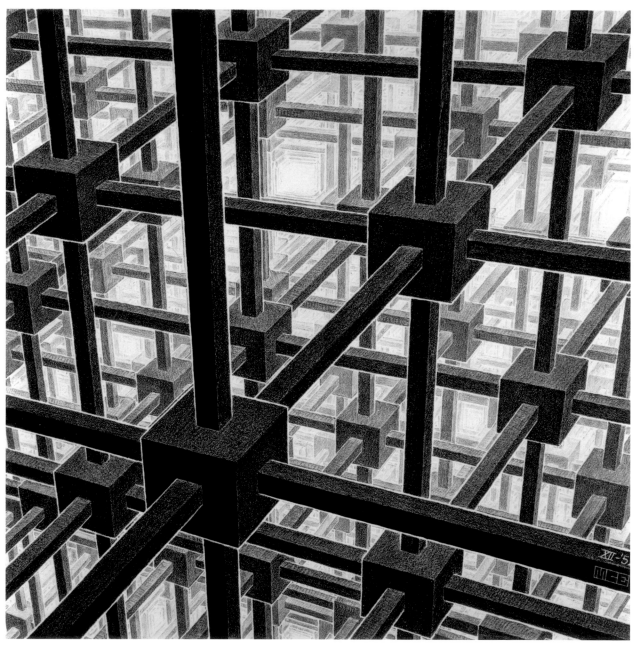

Cubic Space Division, 1952, Lithograph, 10 1/2" x 10 1/2"
B. 386

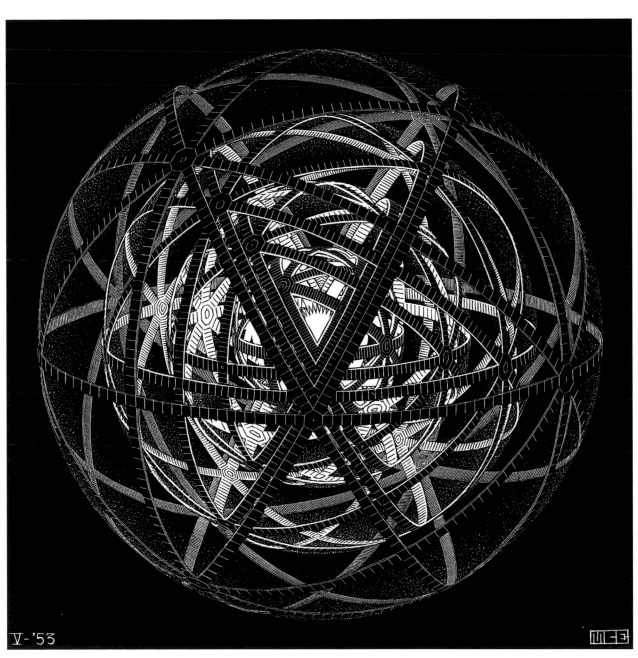

Concentric Rinds, 1953, wood engraving, 9 1/2" x 9 1/2"
B. 387

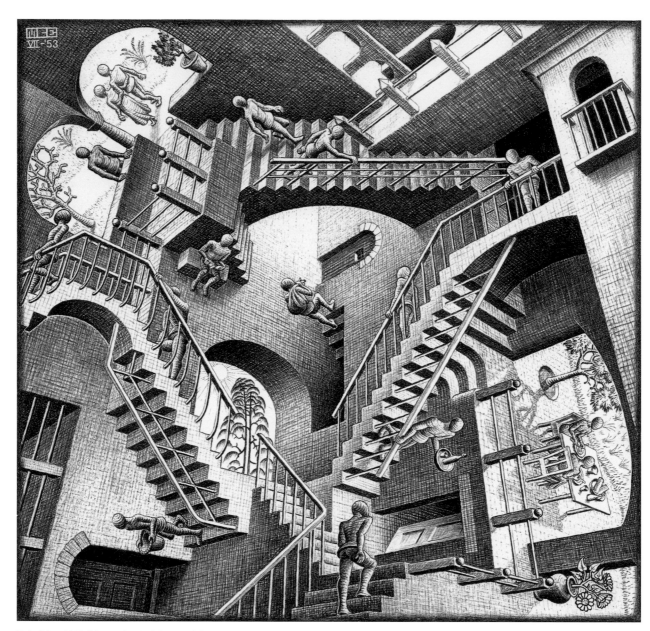

Relativity, 1953, lithograph, 10 7/8" x 11 1/2"
B. 389

Squirrels, Birds and Trees, 1953, wood engraving, 1 3/4" x 3 7/8"
B. 391

Spirals, 1953, wood engraving, 19 5/8" x 13 1/8"
B. 390

E is een Ezel (Donkey), 1953, wood engraving,
3 7/8" x 2 1/2", B. 392

M is een Muis (Mouse), 1953, woodcut, 3 7/8" x 2 1/2"
B. 393

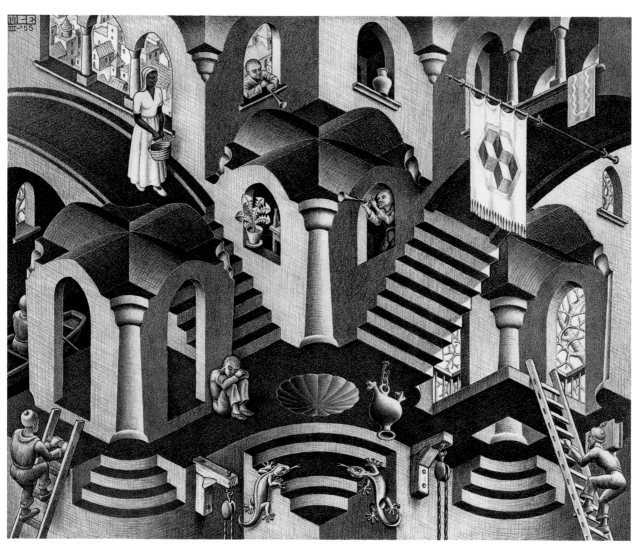

Convex and Concave, 1950, lithograph, 10 7/8" x 13 1/4"
B. 399

M.C. Escher asked the question, "Are you really sure that a floor can't also be a ceiling?"

Convex and Concave represents the portrayed perspective at its best. When you cover the right half of the image you have a birds-eye view of a completely possible scene. Now cover the left half and you still have a scene that does not defy any rules of perspective. But placing the two halves side by side causes confusion.

 The seashell shape in the center exemplifies the phenomenon Escher illustrated. Cover the entire image except for that shape. Without any other reference it is impossible to tell if that shape is a dimple in a smooth floor, or if it is protruding downward from a ceiling.

Escher answered his question for us by illustrating that a floor also can be a ceiling. As he once remarked, "I think it's in my basement...let me go upstairs and check."

A

B

C

D

E

F

G

H

131

I

J

K

L

Preparatory sketches for **Convex and Concave (A - L)**, circa 1950

Preparatory sketches for *Convex and Concave*. Some sketches are for a twisting staircase that changes its point of perspective. This staircase did not appear in any final prints.

Media, dimensions, Hague Museum "T" numbers, and microfiche numbers for the drawings for *Convex and Concave* are to be found in the Index on page 173.

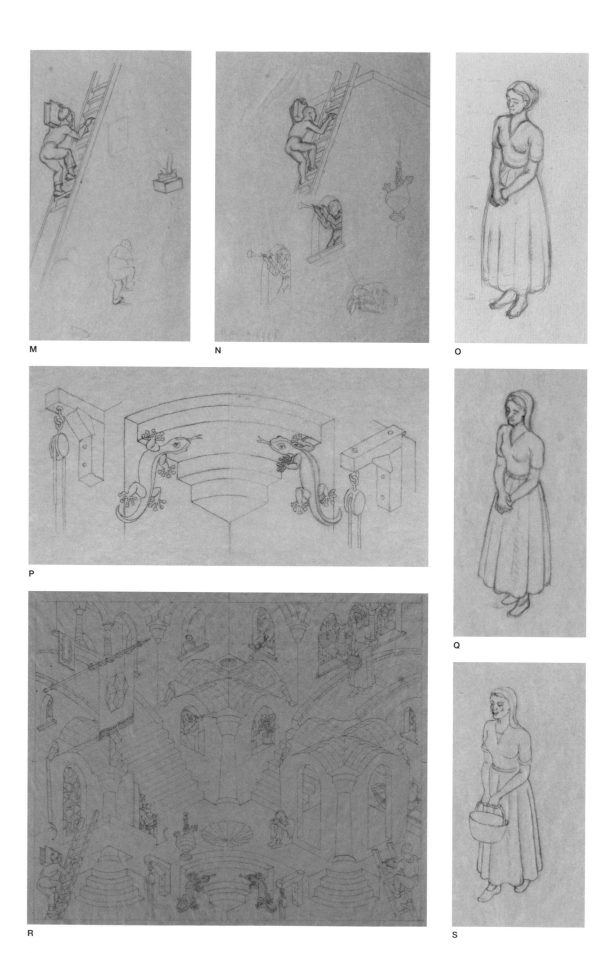

M

N

O

P

Q

R

S

132

Preparatory sketches for **Convex and Concave (M - S)**

Media, dimensions, Hague Museum "T" numbers, and microfiche numbers for the drawings for *Convex and Concave* are to be found in the Index on page 173.

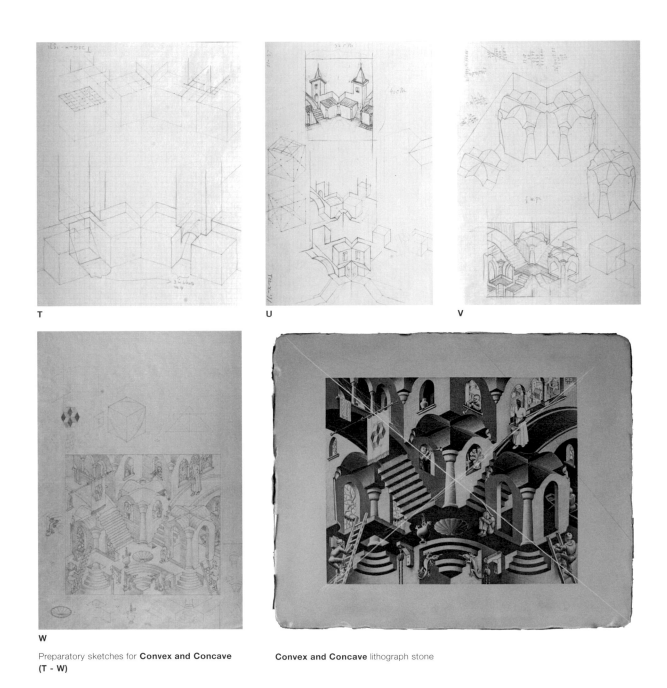

T U V

W

Preparatory sketches for **Convex and Concave**
(T - W)

Convex and Concave lithograph stone

133

The drawings demonstrate the creative process. Escher worked on a variety of perspectives and building plans before finding the best one. The final lithograph stone has an 'x' scratched across it so that it can no longer be printed.

Media, dimensions, Hague Museum "T" numbers, and microfiche numbers for the drawings for *Convex and Concave* are to be found in the Index on page 173.

134

Liberation, 1955, lithograph, 17 1/8" x 7 7/8"
B. 400

Notice that the some of the tessellated birds in *Liberation* are a mirror image of the birds utilized in *Sun & Moon*.

Rind, 1955, woodcut and wood engraving printed from four blocks, 13 5/8" x 9 1/4"
B. 401

Escher commented that this print was inspired by the H.G. Wells book *The Invisible Man*. He was not satisfied with the loose ends, and subsequently created *Bond of Union* (p. 144) to make one continuous ribbon.

Here is a pentagon with a star in it. We are looking at it from the ceiling. In the second image the blue dot has been added above the image. And the lines from each corner to make a glass prism have been added in the third image. This prism has a pentagonal base and five triangular sides.

This is what we are looking at when we look at the front of *Compass Card*. It is not a three-dimensional star. It is Escher once again playing with two and three dimensions at the same time, much like *Three Spheres*.

A three-dimensional star would actually look like the one to the right. Notice the extra lines denoting where the sides meet.

In the next three images the dodecahedron with stars on every side has had a point put above every star. Each corner of the pentagon is connected to the point floating in space above it.

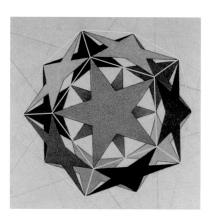

Making a dodecahedron into a stellated dodecahedron adds many sides. In the picture to the right some of the crystal's sides have been colored to show the pattern they create. Once again, this shows that the gray star is within the crystal and not three dimensional.

Escher had great appreciation for crystals. He wrote, "Then came a day when, for the very first time, a human being perceived one of these glittering fragments of regularity, or maybe he struck against it with his stone ax, it broke away and fell at his feet, then he picked it up and gazed at it lying there in his open hand. And he marveled."

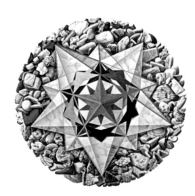

No image better expresses the marvel of something so beautiful existing within such a chaotic environment.

138

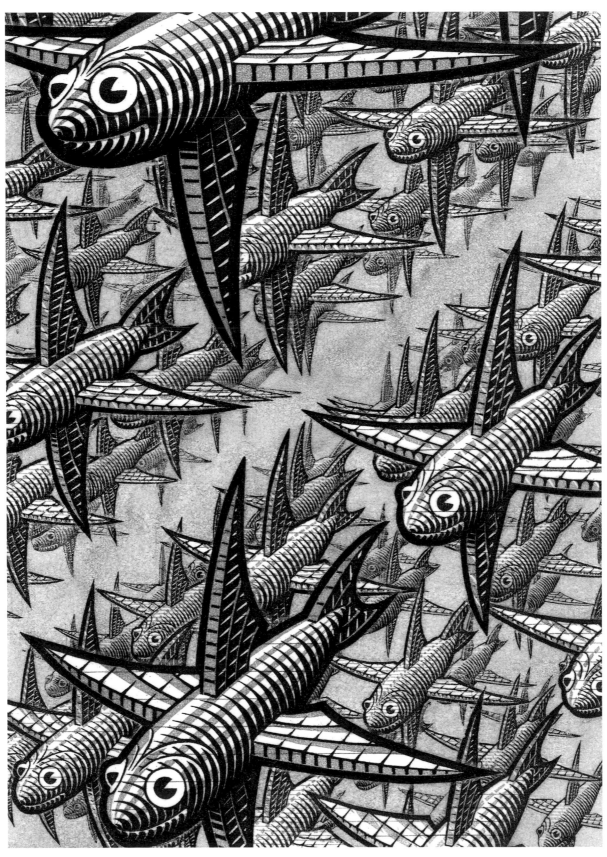

Depth, 1955, woodcut and wood engraving printed from three blocks, 12 5/8" x 9"
B. 403

Three Worlds:
Evolution of a Fish
Creation of a Lithograph

Every piece of artwork begins with an idea; the recognition that *something* is art. How many thoughts pass through an artist's head to be neglected or dismissed? How many scenes does a photographer scrutinize before being inspired to snap the shutter?

A simple walk through nature inspired Escher to create *Three Worlds*. But why *three* worlds?

This print arose at the same time, in the same year, that Escher devoted much of his time to two worlds co-existing: contiguous but independent of one another. Earlier that year he had completed the lithograph *Convex and Concave*, which shows two scenes that can exist independently, but together create confusion. Previously, Escher created *Double Planetoid*, two interlocked tetrahedral planets, one Jurassic, the other modern man.

A

Again, why *three* worlds? On that afternoon, standing on a bridge Escher could see three separate worlds. First, the underwater world ruled by fish. Second, a world on the surface of the water littered with leaves. And, the last world is the one outside the water, but reflected in it. Of course, these worlds are not completely independent. The leaves pass through all three; falling from trees they float on the water until they sink and become the detritus on the lake's bottom.

Perhaps the fish alone provided inspiration. Fish inspire many of Escher's tessellations. A closer look at the fish reveals that its skin is a tessellation in itself. Later, fish scales served as the symmetry grid for the woodcut *Fishes and Scales*.

B

C

D

E

Preparation followed inspiration; Escher meticulously constructed the future compositions. The preliminary drawings show how the fish evolved both in perspective and appearance. The grid for scales rivals any grid symmetry created for his other tessellations.

The trees and their reflections were created on separate pieces of paper and tracing paper. The leaves fill a perspective plane akin to the future intersecting planes works (see *Three Intersecting Planes*).

Escher did not leave anything to chance when creating a lithograph. The final "sketch" is an exact tracing of the future print.

Study for Three Worlds, 1955 – shaded fish, pencil, 8 5/8" by 6 1/4"
T139-x-1971, microfiche 341

But what is a lithograph? "Litho" is Greek for stone. "Graph" means print. This stone print is made by drawing an image onto a smooth stone surface with an oil-based ink. The rest of the stone is then coated in a solution containing gum Arabic and nitric acid. The acids make the limestone surface hydrophilic (water-loving) anywhere it is white. The oil-based ink repels water. The stone is then wetted, but the water only stays on the white areas. Then, oil-based pigment is applied to the whole stone. The water repels the ink, but the ink sticks to the areas the artist drew on. A piece of paper is placed on the stone and the two are run through a press. The paper picks up the ink from the stone and a print is completed.

141

Escher transferred his image to the stone using tracing paper (see the trees below). Then he used a grease pencil to fill in the black and gray tones on the stone. The stone image is a mirror-image of the final artwork. Although Escher printed his own woodblocks, he trusted his stones to a lithograph printer.

And that is how a simple afternoon walk in this world became *Three Worlds*.

F

G

H

Media, dimensions, Hague Museum "T" numbers, and microfiche numbers for the drawings for *Three Worlds* are to be found in the Index on page 173.
Information will be given by the letter that represents the piece's position on the page.

Final study for Three Worlds, 1955, pencil on tracing paper, 16 3/4" x 12 1/4"
T142-x-1971, microfiche 333

142

Study for Three Worlds, 1955, pencil on tracing paper, 16 3/4" x 12 1/4"
T143-x-1971, microfiche 334

Three Worlds stone, 1955, lithography stone, canceled

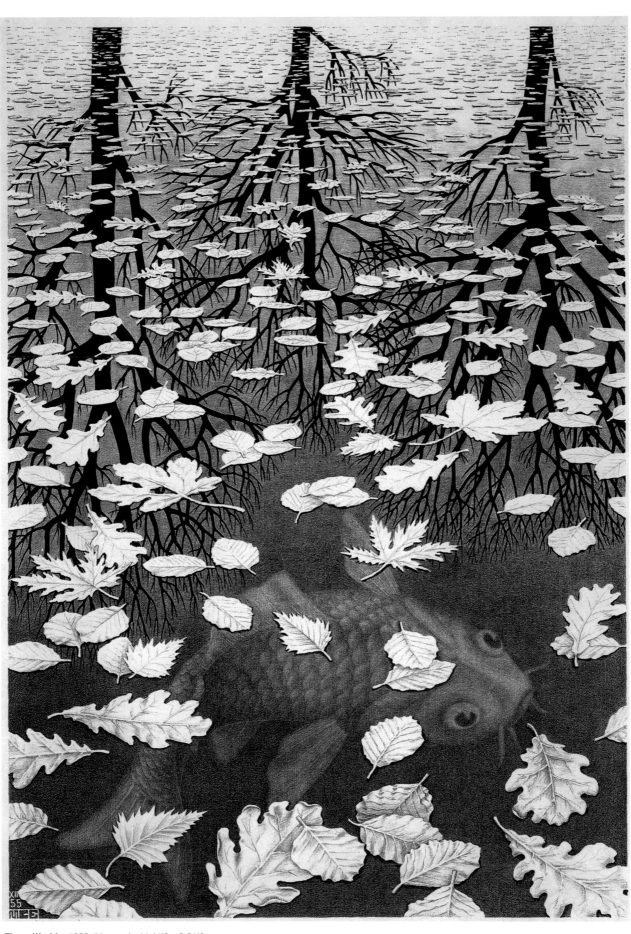

Three Worlds, 1955, lithograph, 14 1/4" x 9 3/4"
B. 405

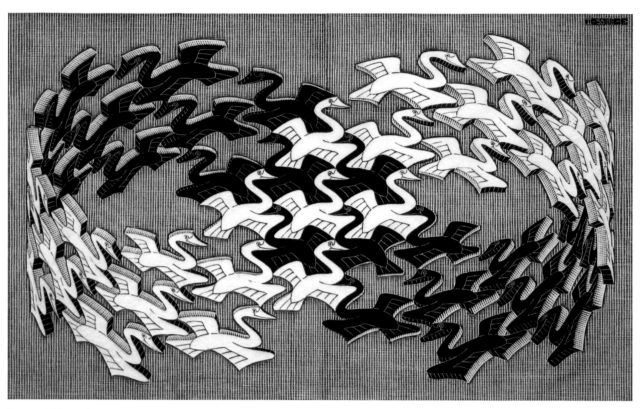

Swans, 1956, wood engraving, 7 7/8" x 12 1/2"
B. 408

144

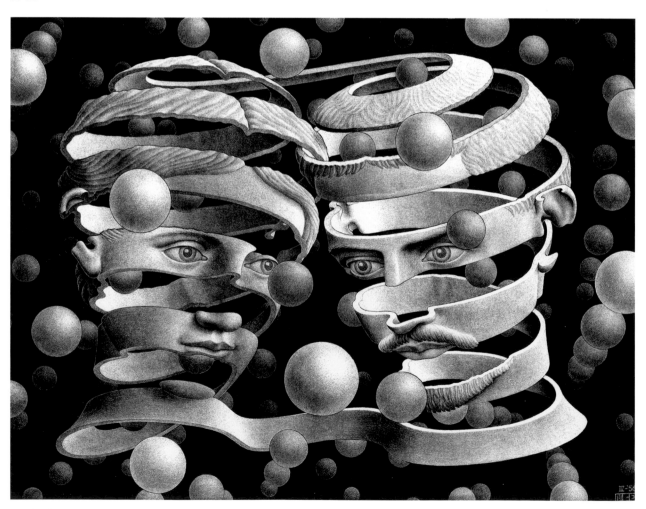

Bond of Union, 1956, lithograph, 10" x 13 3/8"
B. 409

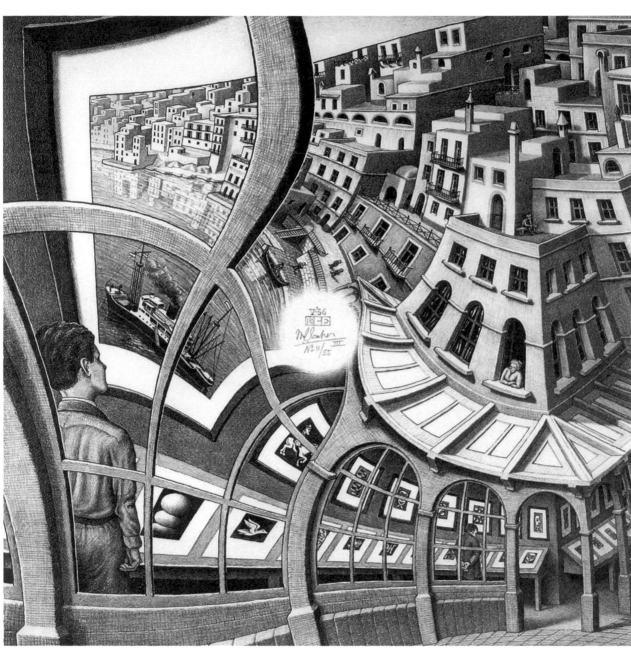

Print Gallery, 1956, lithograph, 12 1/2" x 12 1/2"
B. 410

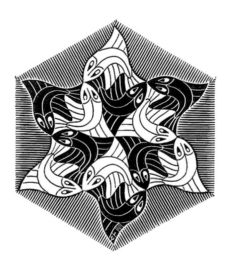

Hexagonal Fish, 1955, woodcut, 3 1/2" x 3"
B. 406

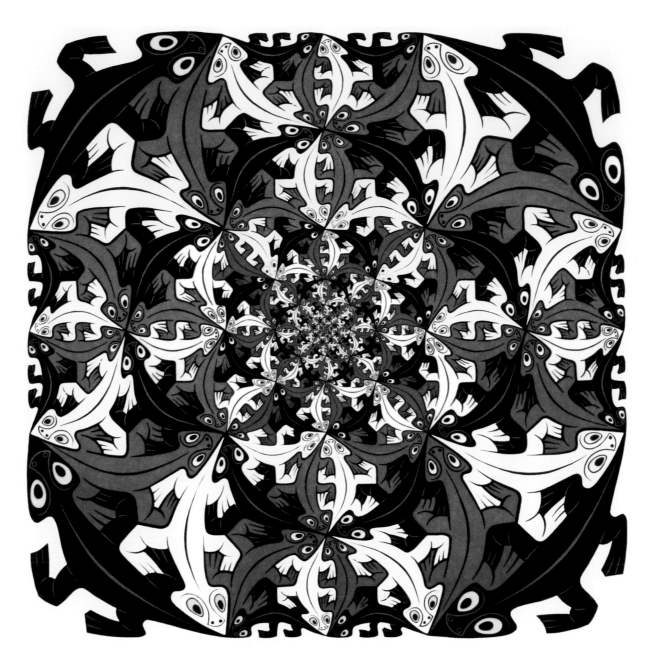

146

Smaller and Smaller, 1956, woodcut and wood engraving printed from four blocks, 15" x 15"
B. 413

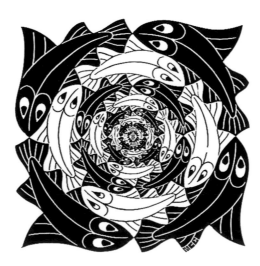

Concentric Fish, 1956, wood engraving, 3 1/4" x 3 1/4"
B. 414

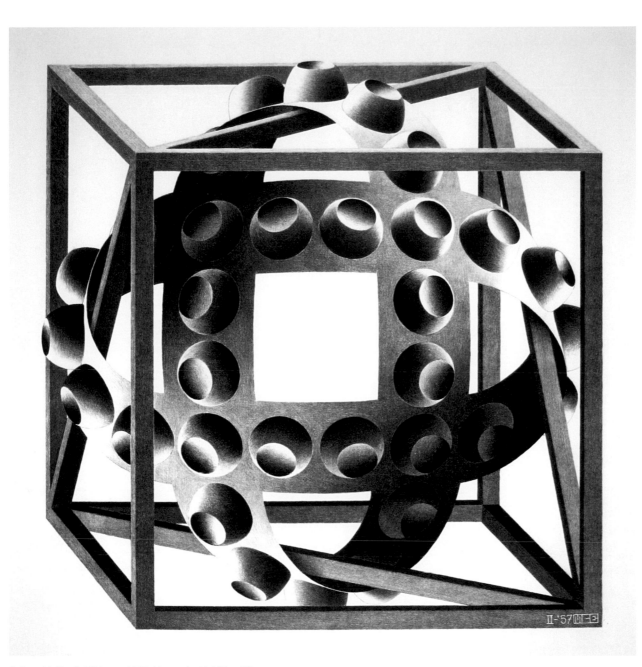

Cube with Magic Ribbons, 1957, lithograph, 12 1/8" x 12"
B. 415

Flying Envelopes, New Year's Greeting Card, 1956, woodcut,
5 3/8" x 6", B. 412

Regular Division of the Plane

In 1957 the De Roos Foundation commissioned Escher to write an essay on his tessellation work. In 1958 the essay was published as a book entitled *Regelmatige Vlakverdeling* (The Regular Division of the Plane). The book contained six black woodcuts bound within its pages and six loose woodcuts printed in red ink that were included in a separate band in the back cover of the book.

Escher wrote the book to describe tessellations and different ways in which shapes can rotate, reflect, or glide to fill a plane. The short book is full of many asides ranging from metamorphosis to dimensionality to observations that he is a lone artist in a unique genre. Escher revealed a little about his personality when he concluded with an acknowledgment to Bach; "his rationality, his mathematical order and the strictness of his rules probably have much to do with this, though not directly...I reach out to Bach's music to revive and fire my desire for creativity."

Regular Division of the Plane, 1957, Woodcuts printed in both black and red, 9 1/2" x 7 1/8"
B. 416-421

Regular Division of the Plane, 1957, Woodcut, 9 1/2" x 7 1/8"
B. 416

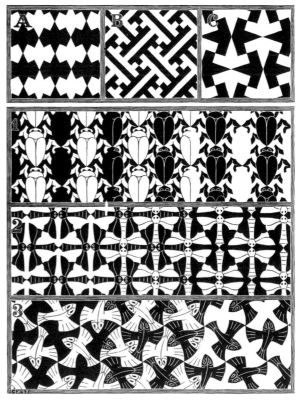

Regular Division of the Plane, 1957, Woodcut, 9 1/2" x 7 1/8"
B. 417

148

Regular Division of the Plane, 1957, Woodcut, 9 1/2" x 7 1/8"
B. 418

Regular Division of the Plane, 1957, Woodcut, 9 1/2" x 7 1/8"
B. 419

Regular Division of the Plane, 1957, Woodcut, 9 1/2" x 7 1/8"
B. 420

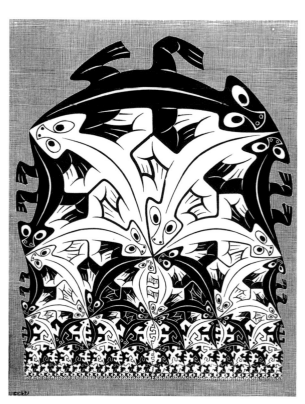

Regular Division of the Plane, 1957, Woodcut, 9 1/2" x 7 1/8"
B. 421

Mosaic II (Plane Filling II), 1957, lithograph, 12 3/8" x 14 5/8"
B. 422

The only rule for *Mosaic II* was that each figure be bordered only by figures of the opposite color. Escher said this of his mosaic pieces, "the only reason for their existence is one's enjoyment of this difficult game, without any ulterior motive."

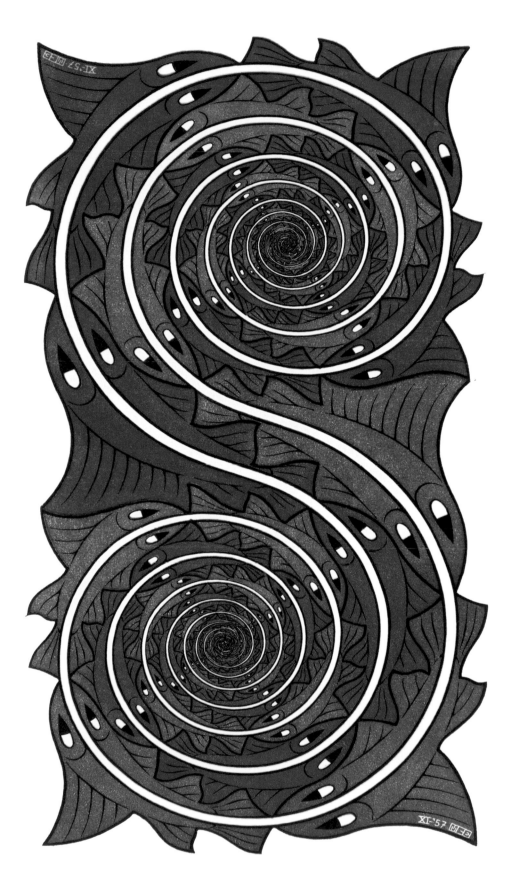

Whirlpools, 1957, woodcut and wood engraving printed from two blocks, 17 1/4" x 9 1/4"
B. 423

151

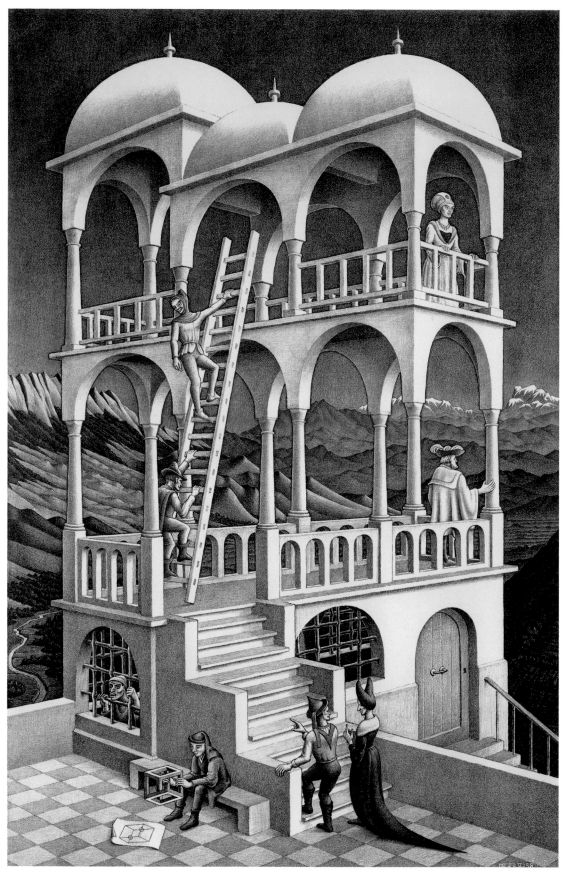

Belvedere, 1958, lithograph, 18 1/4" x 11 5/8"
B. 426

Only those who attempt the absurd will achieve the impossible. – M.C. Escher

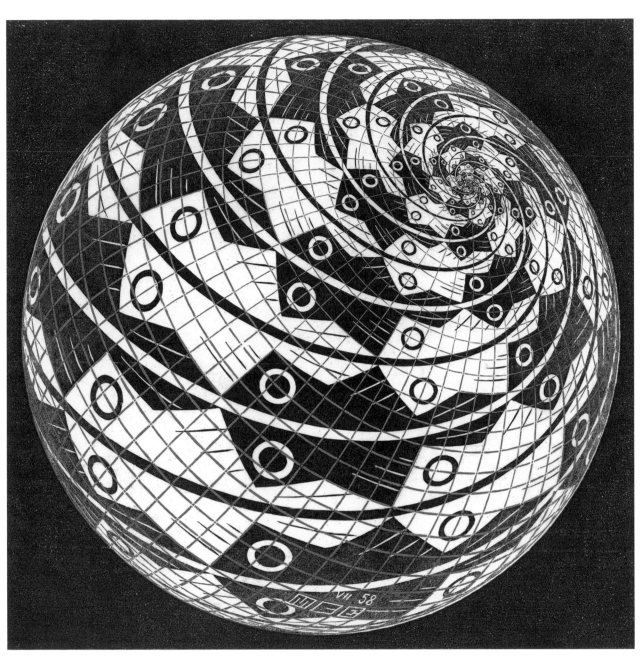

Sphere Surface with Fish, 1958, woodcut and linocut, 13 3/8" x 13 3/8"
B. 427

Sphere Surface with Fish, 1958, woodcut before addition
of the linoleum block, 13 3/8" x 13 3/8", B. 427

154

Flatworms, 1959, lithograph, 13 1/4" x 16 1/4"
B. 431

Bricks are usually rectangular, because in that way they are most suitable for building the vertical walls of our houses. But anyone who has anything to do with the stacking of stones of a non-cubic type will be well aware of other possibilities. For instance, one can make use of tetrahedrons alternating with octahedrons. Such are the basic shapes which are used to raise the building illustrated here. They are not practicable for human beings to build with, because they make neither vertical walls nor horizontal floors. However, when this building is filled with water, flatworms can swim in it. – M.C. Escher from *M.C. Escher: The Graphic Work*

preliminary drawing for Fish and Scales, circa 1959, crayon, 13 5/8" x 13 5/8"
T454-x-1971, microfiche 782

preliminary drawing for Fishes and Scales, circa 1959,
pencil, 13 3/4" x 15 3/8"
T445-x-1971, microfiche 926

preliminary drawing for Fishes and Scales, circa 1959,
pencil, 14 3/4" x 15"
T456-x-1971, microfiche 1355

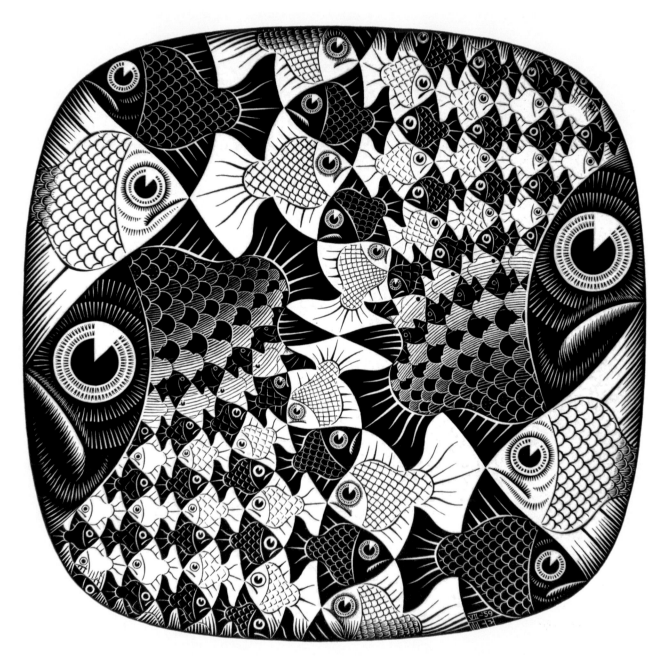

156

Fish and Scales, 1959, woodcut, 14 7/8" x 14 7/8"
B. 433

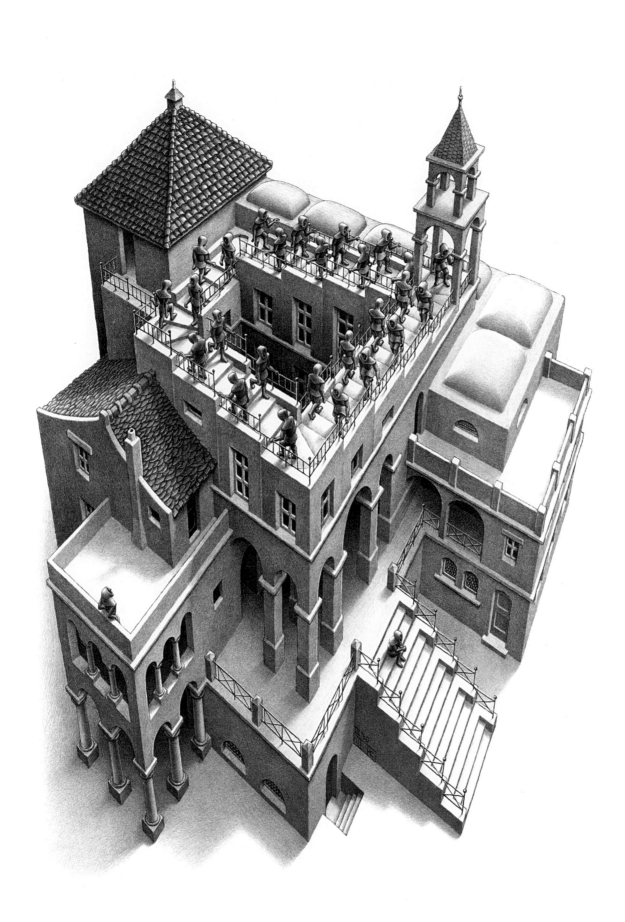

Ascending and Descending, 1960, lithograph, 14" x 11 1/4"
B. 435

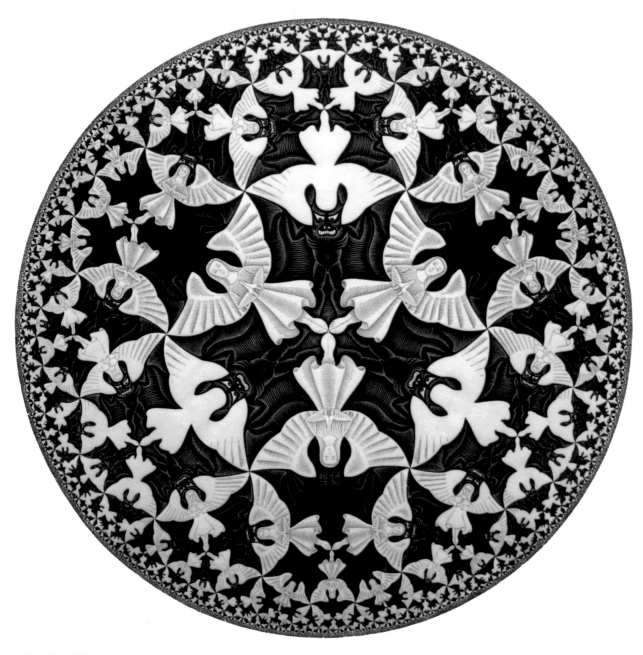

158

Circle Limit IV (Angels and Devils), 1960, woodcut printed from two blocks, 16 3/8" diameter
B. 436

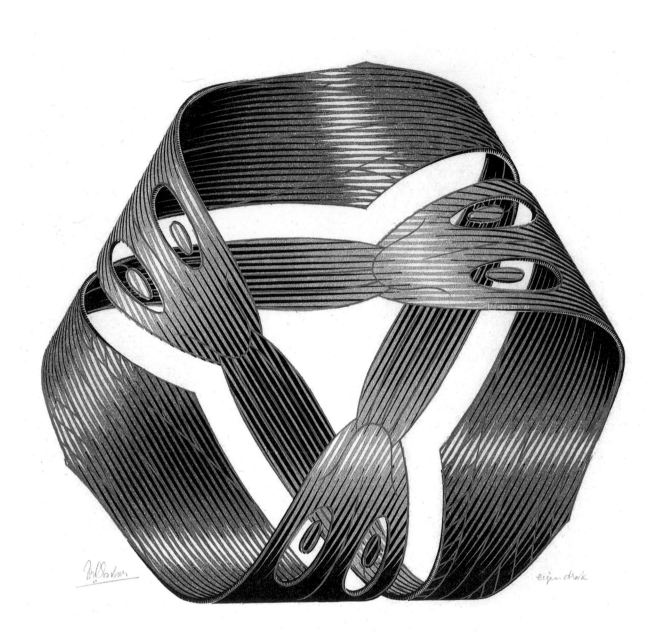

159

Moebius Strip I, 1960, woodcut, engraving and linocut printed from four blocks, 9 3/8" x 10 1/4"
B. 437

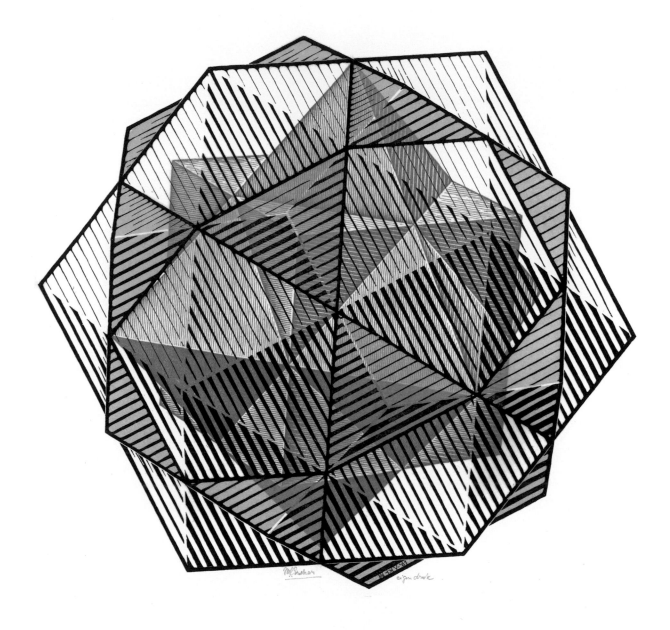

Four Regular Solids (Stereometric Figure), 1961, woodcut printed from three blocks, 13 7/8" x 15 3/8"
B. 438

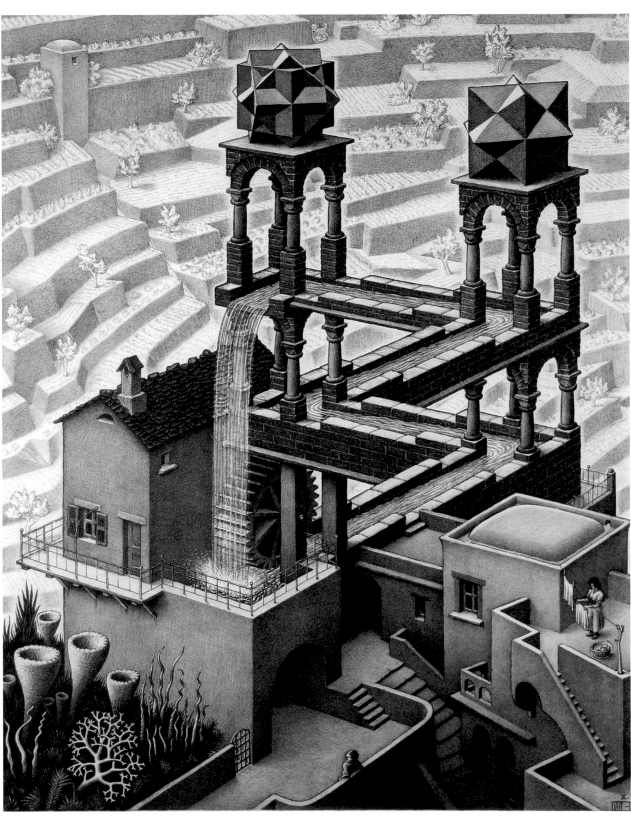

Waterfall, 1961, lithograph, 15" x 11 3/4"
B. 439

The water from a waterfall, which sets in motion a miller's wheel, zigzags gently down through a gutter between two towers until it reaches the point from which it falls down again. The miller can keep it perpetually moving by adding a bucket of water every now and then to check the evaporation. — M.C. Escher from *M.C. Escher: The Graphic Work*

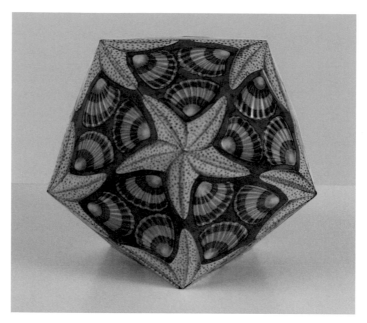

Verblifa cookie tin, 1963

Verblifa cookie tin sheet, uncut

The Verblifa company commissioned Escher to devise a candy tin design for their 75th anniversary. He created a unique icosahedron-shaped tin decorated by a seashell and starfish tessellation. Notice that the uncut starfish have six legs. To construct the tin, a single slit is made from one corner of the hexagon template to the center. Then, the hexagon is folded so that two triangular components neighboring the slit, overlap. The overlapping limbs create a five-legged starfish. At the same time, a two-dimensional hexagon becomes a three-dimensional object in an Escher-like fashion.

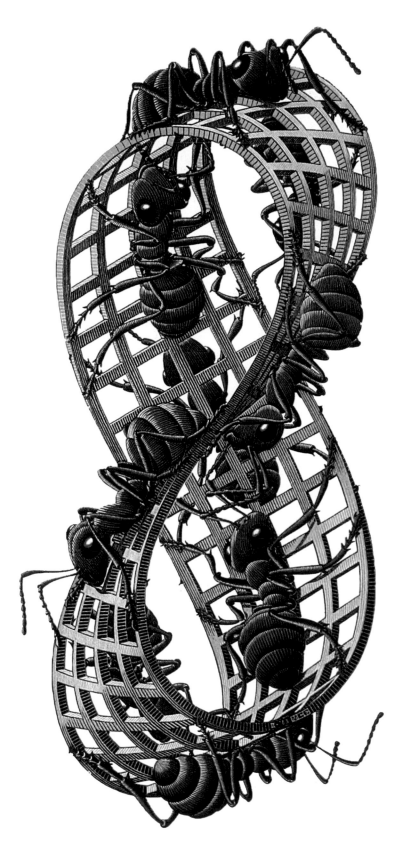

Moebius Strip II (Ants), 1963, woodcut printed from three blocks, 17 7/8" x 8 1/8"
B. 441

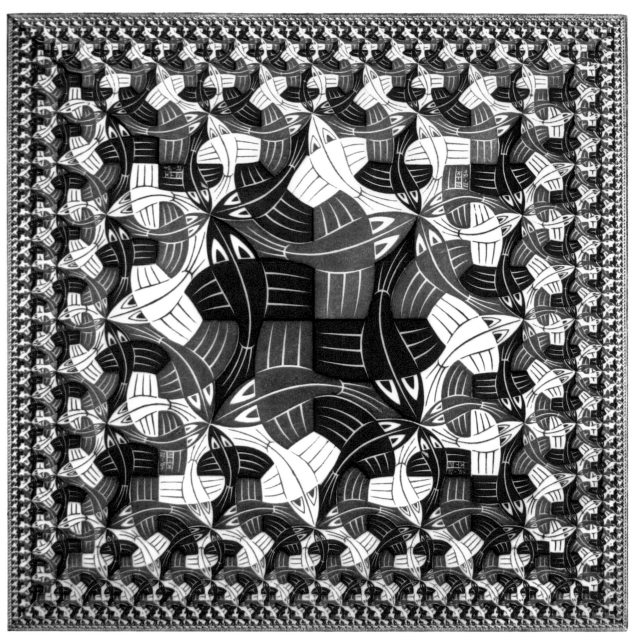

Square Limit, 1964, woodcut printed from two blocks, 13 3/8" x 13 3/8"
B. 443

Pine Cone, 1961, wood engraving, 3" x 3"
B. 440

Fishes in Waves, 1963, woodcut, 4 1/4" by 4 1/4"
B. 442

Knots, 1965, woodcut printed from three blocks, 16 7/8" x 12 5/8"
B. 444

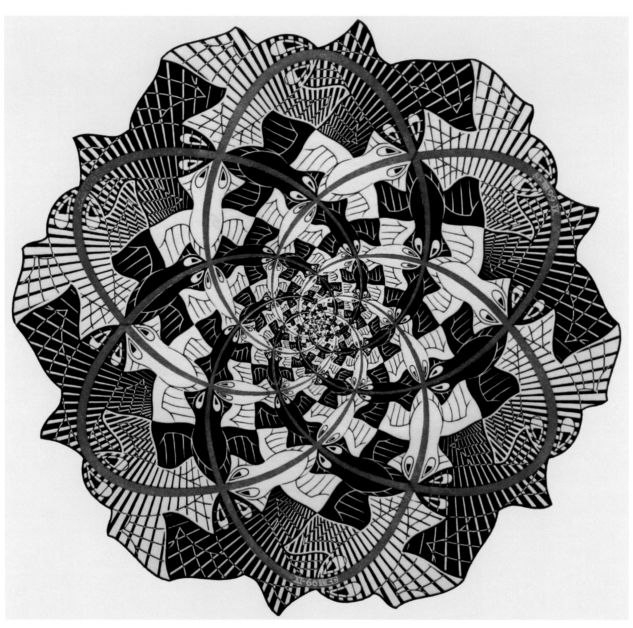

Path of Life III, 1966, woodcut printed from two blocks, 14 3/8" x 14 5/8"
B. 445

Boats, Fishes, Horses, Flying Envelopes, Birds from Metamorphosis II, 1968, woodcut, 7 1/2" x 61 1/2"
B. 446

Bees, from Metamorphosis III, 1968, woodcut, 7 1/2" x 22 1/2"
B. 446

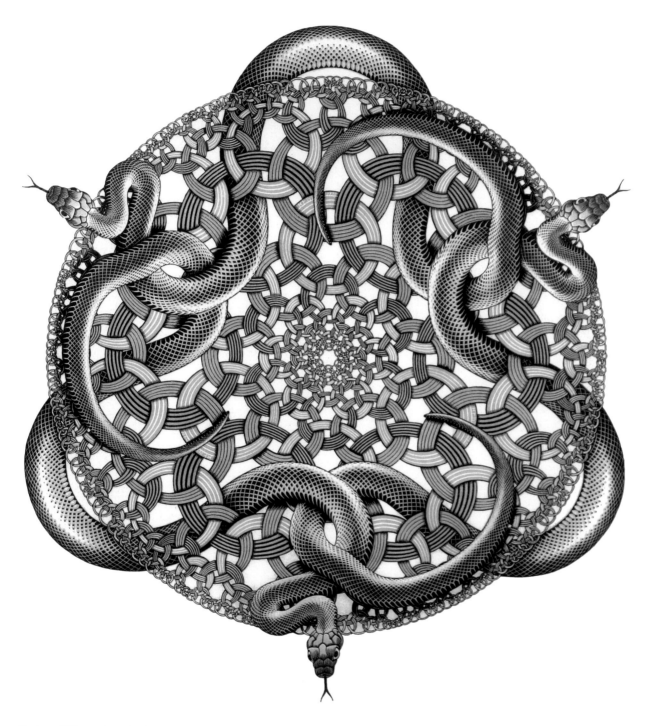

Snakes, 1969, woodcut printed from three blocks, 19 5/8" by 17 5/8"
B. 448

He who wonders discovers that this in itself is a wonder.

– M.C. Escher

Finis Vignette (from Scholastica), 1932, woodcut, 2 1/4" x 3 1/8", B. 205

M.C. Escher Biographical Timeline

1898 Maurits Cornelis Escher was born June 17 in Leeuwarden, Holland.

1916 M.C. Escher produced his first graphic work, a linoleum cut portrait of his father (B. 1)

1919-22 Escher attended the School for Architecture and Decorative Arts in Haarlem.

Flor de Pascua by A.P. van Stolk, illustrated with woodcuts by Escher, was published.

Escher produced *Eight Heads*, a woodcut (B. 90), his first regular division of the plane.

1922-35 En route to Italy, Escher visited the Alhambra, the Moorish Palace in Granada, Spain.

Escher lived in Italy—in Siena, Ravello and Rome.

Escher's first one-man exhibition was held in Siena.

Escher's first exhibition in Holland was held.

Escher and Jetta Umiker were married.

1926 An exhibition of Escher's work was held in Rome.

Escher's first son, George A. Escher, was born.

1928-31 Escher's second son, Arthur E. Escher, was born.

XXIV Emblemata, with epigrams by A.E. Drijfhout and woodcuts by Escher, was published.

De vreeselijke avonturen van Scholastica by Jan Walch, illustrated with woodcuts by Escher, was published.

Escher was awarded third prize at a Chicago exhibition for his lithograph *Nonza, Corsica* (B. 247).

1935-37 An exhibition of Escher's work was held at the Dutch Historical Institute in Rome.

1936 Escher lived in Switzerland. He made a second visit to the Alhambra in Granada and also visited the mosque in Cordoba, Spain.

1937-41 Escher lived in Brussels, Belgium.

1938 Escher's third son, Jan C. Escher, was born.

1941 Escher moved to Baarn. He resided in Holland the rest of his life.

1954 Escher's one-man exhibition was held at the Stedelijk Museum in Amsterdam in conjunction with the International Congress of Mathematicians.

An exhibition of Escher's work was held in the Whyte Gallery, Washington, D.C.

1958 *Regelmatige vlakverdeling (The Regular Division of the Plane)*, written and illustrated (B. 416-421) by Escher, was published.

1959 *Grafiek en tekeningen M.C. Escher (The Graphic Work of M.C. Escher)* was published.

1960 Escher lectured and exhibited his work in Cambridge, England, in conjunction with the Congress of the International Union of Crystallography.

1965 *Symmetry Aspects of M. C. Escher's Periodic Drawings* by Caroline H. MacGillavry, a crystallographer, was published.

1968 A major exhibition of Escher's work was held at the Gemeentemuseum in The Hague.

1969 Escher produced the woodcut Snakes (B. 448), his last graphic work.

1972 Escher died at age 73, on March 27, in the hospital in Hilversum.

170

Index

All drawings and watercolors are in italics. Woodcuts, lithographs, and mezzotints are in regular font.
All artwork from the collection Rock J. Walker and Walker Fine Art, Inc. except:
• From the Private Collection of Marc Bell

4 Graphic Artists	121
7 Black and 6 White Fishes	129
Alhambra tiling pattern	75
Aloe plant in Tropea	40
• *Another World* (Other World)	101
Armor hands and gauntlets	59
• Ascending and Descending	157
Baby	30
Balcony	92
Banknote study	87
Barbarano	38
Basilica of Constantine	67
Bees, from Metamorphosis III	167
• Belvedere	152
Between St. Peter's & the Sistine Chapel	73
Between St. Peter's & the Sistine Chapel	73
Birds and Ponies	108
Black Raven (St. Vincent Martyr)	27
• Bond of Union	144
Borger Oak	20
Boulders near the water	16
Bridge	42
Calascibetta	43
Calvi	60
Canteen at Steckborn	49
Capital above the door of San Jacopo	20
Casas Colgantes, Cuenca	73
Castel Mola and Mt. Etna, Sicily	58
Castle in the Air	31
Castrovalva	41
Castrovalva drawing	40
Cathedral of Cefalu, Sicily	58
Cattolica di Stilo	45
Ceramic plate study	112
Chiesa dell Ospedale, Ravello	56
Circle Limit IV (Angels and Devils)	158
Circular Fish	146
Cloister of Rocca Imperiale	48
Cloister of San Monreale, Sicily	59
Coast near Saint Raphael	20
Cobwebs	50
Colonnade of St. Peter	66
Colosseum	67
Column with grotesque figures	28
Concentric Fish	146
Concentric Rinds	125
• Convex and Concave	130
Convex and Concave studies	131-3
Covered Alley in Atrani	50
Crystal	102
Cube with Magic Ribbons	147
Cubic Space Division	124
Curl-Up	116
Cycle	76
• Day and Night	75
De Vreeselijke Avonturen van Scholastica	54-5
• Depth	139
Development I	74
Development II	78
Devils vignette	91
Dolphins in Phosphorescent Sea	25
Doric Columns	94
Double Planetoid	109
• Dragon	122
• Drawing Hands	105
Dream	71
E is een Ezel (Donkey)	127
Emblemata (XXIV Emblemata)	51-3
• Encounter	91
Ex libris 's-Gravesande (Open Book)	96
Ex libris B.G Escher	96
Ex libris Bosman (Bookworm)	97
Ex libris de Bruyn (Vaulted Window)	97
Ex libris D.H. Roodhuyzen	96
Ex libris Travaglino (Still Life on Table)	96
Ex libris van Dishoeck (Fire)	97
Ex libris Wertheim (Scales)	97
• Eye	99
Farm and Hills	44
Finis Vignette	169
Fir tree	18
Fire from the Four Elements study	123
Fireworks	63
Fish and Scales	156
Fish and Scales drawings	155
Fishes and Boats	106
Fishes and Frogs	108
Fishes in Waves	164
Fiumara of Stilo, Calabria	45
Flatworms	154
Flor de Pascua	22
Flowers	17
Flying Envelopes, New Year's Card	147
Four Elements	123
Four Fish and One Bird	118
Four Regular Solids (Stereometric Figure)	160
G.A. Escher, Portrait of	72
Gallery (Another World)	100
George A. Escher, as a baby	30
Goriano Sicoli	37
Grasshopper	70
Gulf of Porto, Corsica	65
Hand with Reflecting Sphere	68
Heavy Heart	74
• Hell (from a painting by Hieronymus Bosch)	72
Hexagonal Fish	145
• High and Low (Up and Down)	103
Hills	17
Holy figures	43
Horsemen	98
House of Stairs	117
Il Diavolo di Ravello	44
Infant	30
Inside St. Peter's	69
Intarsia panel study - fish and birds	119
Knots	165
Lava Flow, Sicily	63
Liberation	134
Lighthouse	17
Lilies	50

All drawings and watercolors are in italics. Woodcuts, lithographs, and mezzotints are in regular font.
All artwork from the collection Rock J. Walker and Walker Fine Art, Inc. except:
• From the Private Collection of Marc Bell

Lion of the Fountain in the Piazza at Ravello	57
Lizards Tiling Motif	90
M is een Muis (Mouse)	127
Madonna del Parto Sutri	29
• Magic Mirror	95
• Metamorphosis II	79
Metamorphosis III segments	167
• Moebius Strip I	159
Moebius Strip II (Ants)	163
Monte St. Angelo	44
Mosaic I (Plane Filling I)	116
Mosaic II (Plane Filling II)	150
Motto "Hutspot"	111
Mummified Frog	99
Nocturnal Rome	66-7
Nude	17
Old Olive Tree, Corsica	64
Old Olive Tree woodblock	64
• Order and Chaos (Contrast)	114
Order and Chaos II (Compass Card)	136
Other World	101
Owl (Diploma)	93
Owl (Diploma) drawing and block	93
Palermo	72
Palizzi	43
Palm	61
Palm woodblocks	60
• Path of Life III	166
Pentedattilo	46
Pescostanzo	38
Phosphorescent Sea	62
Pine Cone	164
Pizzo	44
Pizzo, 29-4-'30	43
• Plane-filling motif with birds	107
Ponte Di Cecco Astolipic	28
Porta Maria dell'Ospidale, Ravello	56
Portrait of G.A. Escher	72
Predestination	115
• Print Gallery	145
Procession in Crypt	29
• Puddle	121
• Ravello	26
Regular Division of the Plane	148-9
Regular division of the plane study	87
Relativity	126
Reptiles	90
Reversing cubes	80
• Rind	135
Rippled Surface	115
River landscape	16
Rufalo Spiny Plant	40
Saint Francis	21
Saint Matthew Passion	74
San Cosimo, Ravello	56
San Michele dei Frisoni, Rome	57
San Pietro, Tuscania	20
Santa Severina	48
Scanno	38
Scapegoat woodblock	22
Scarabs	70
Scholastica	54-5
Scilla	47
Second Day of Creation	27
Self Portrait ceramic plate	113
Self Portrait in Spherical Mirror	110
Self Portrait watercolor	112
Siena	24
Siena drawings (2)	24
Sketches for damask linen	110
• Sky and Water I	77
• Sky and Water II	77
Smaller and Smaller	146
Snakes	168
Sphere Surface with Fish	153
Spider web design for a plate	111
Spirals	127
Square Limit	164
Squirrels, Birds and Trees	126
Stars	106
Still Life with Mirror	65
Street in Scanno, Abruzzi	39
Study for Another World	100
Study for Drawing Hands	105
Study of hands	59
Study of Dutch stamp	59
• Sun and Moon	104
Sunflowers	19
Swans	144
Symmetry Drawing 9	80
Symmetry Drawing 23	81
Symmetry Drawing 60	82
Symmetry Drawing 94	83
Symmetry Drawing 108	84
Symmetry Drawing 134	85
Symmetry Drawing 136	86
Synthesis	102
Tetrahedral Planetoid	128
The Four Elements	123
Three dimensional map of Europe	121
Three Intersecting Planes	129
• Three Spheres I	95
• Three Spheres II	98
• Three Worlds	143
Three Worlds sketches	140-2
Tile for column, ceramic	87
Tournai (Doornik) Cathedral	69
Trajan's Column	66
Tropea	40
Tugboat, Old Harbor of Bastia, Corsica	64
Turello	56
Two Intersecting Planes	118
Unfinished sketch of a hill town in Italy	29
Unicorns	114
Verbalifa candy tin	162
Verbum	89
Vernazza 47 Vitorchiano	26
Vitorchiano	28
Watercolor for fish intarsia	119
• Waterfall	161
Well	108
• Whirlpools	151
Winding Road	16
Window view onto courtyard	25

Convex and Concave Drawings

All drawings are in pencil.

A. 19 3/8" x 15"
T339-x-1971
microfiche 1467

B. 3 1/4" x 3 3/8"
T334-x-1971 verso
microfiche 1463

C. 15 5/8" x 23 3/4"
T23-x-1971 recto
microfiche 1505

D. 7 7/8" x 6 5/8"
T48-x-1971 recto
microfiche 1462

E. 5 1/2" x 8 1/4"
T48-x-1971 verso
microfiche 1462

F. 21" x 14 5/8"
T47-x-1971 verso
microfiche 1699

G. 7 1/2" x 9 3/4"
T329-x-1971
microfiche 1456

H. 5 7/8" x 8"
T334-x-1971 recto
microfiche 1463

I. 10 5/8" x 7"
T337-x-1971 recto
microfiche 1466

J. 9 3/8" x 8 1/4"
T336-x-1971 verso
microfiche 1465

K. 13 1/4" x 8 1/4"
T328-x-1971
microfiche 1452

L. 8 1/8" x 10 3/4"
T61-x-1971
microfiche 1451

M. 6 3/4" x 4"
T332-x-1971
microfiche 1460

N. 7 1/8" x 5"
T331-x-1971
microfiche 1459

O. 3 1/4" x 1"
T338-x-1971
microfiche 1469

P. 3" x 5 3/4"
T21-x-1971
microfiche 1449

Q. 3 1/4" x 1 1/8"
T324-x-1971
microfiche 1458

R. 11/8" x 13 1/4"
T340-x-1971
microfiche 1468

S. 2 3/4" x 7/8"
T330-x-1971
microfiche 1457

T. 12 7/8" x 5"
T336-x-1971 recto
microfiche 1465

U. 11 7/8" x 8 1/4"
T22-x-1971 recto
microfiche 1450

V. 12 5/8" x 8 1/4"
T22-x-1971 verso
microfiche 1450

W. 21 1/8" x 18"
T47-x-1971 recto
microfiche 1700

Three Worlds Drawings

Pencil unless otherwise stated.

A. 8 5/8" by 6 1/4"
T135-x-1971
microfiche 337

B. 8 5/8" by 6 1/4"
T138-x-1971
microfiche 340

C. 8 5/8" by 6 1/4"
T136-x-1971
microfiche 338

D. 6 1/8" x 8 3/8"
T144-x-1971
microfiche 335

E. 8 5/8" by 6 1/4"
T137-x-1971
microfiche 339

F. Ink
16 3/4" by 12 1/4"
T140-x-1971
microfiche 331

G. Ink
16 5/8" by 12 1/4"
T141-x-1971
microfiche 332

H. 13 3/8" x 12 1/4"
T145-x-1971
microfiche 336

Boca Raton Museum of Art

174